WATERCOLOR FOR THE *fun* OF IT
Getting Started

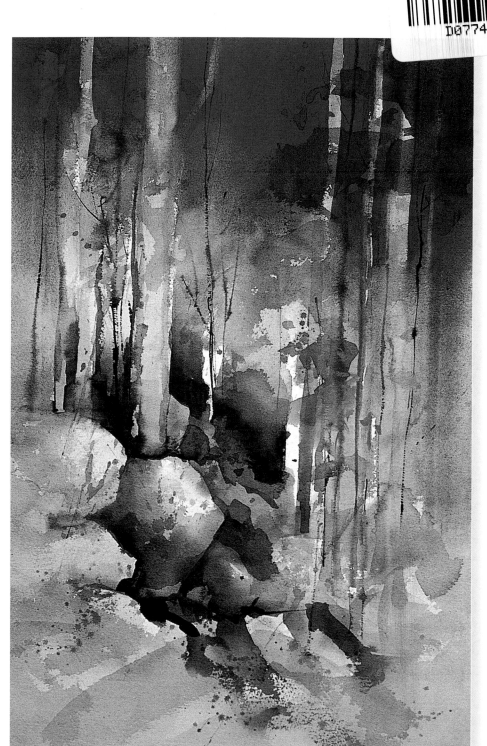

UNDER THE SAPLINGS · 20" × 13" (51cm × 33cm)

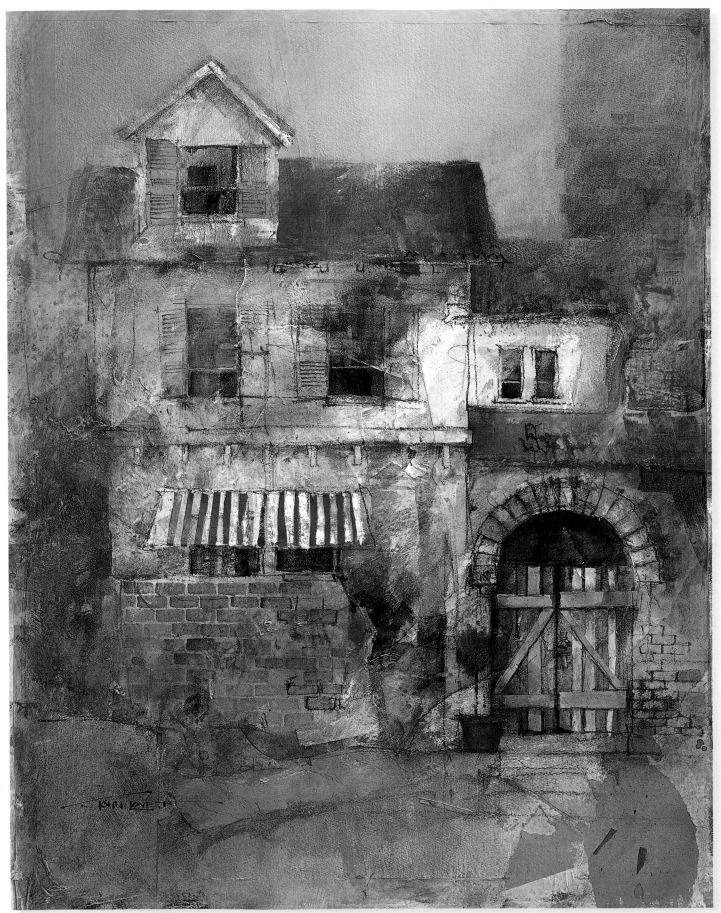

THE GATE · mixed media · 30" × 22" (76cm × 56cm)

WATERCOLOR FOR THE *fun* OF IT
Getting Started

John Lovett

NORTH LIGHT BOOKS
CINCINNATI, OHIO

www.artistsnetwork.com

From an early age, John Lovett's father, Robert, a well-known Australian artist, encouraged him to express himself through art. John received formal training at the National Art School in Newcastle and had his first one-man exhibition in 1973. John has held over twenty solo exhibitions around Australia and has been involved in numerous group exhibitions. John and his family live in Queensland, Australia where he paints and teaches from his studio on Currumbin Creek. John's work is in the Red Hill Gallery in Brisbane, McGrath's Art Gallery in North Sydney, Moulton Galleries in Mosman and Gallery Six in Mona Vale, Sydney. His work has appeared in *Australian Artist* magazine. He has produced his own interactive CD-ROM, *John Lovett Watercolor Studio Workshop*. His work and instruction can also be seen on his Web site at www. johnlovett.com.

Other fine North Light Books are available from your local bookstore, art supply store or direct from the publisher.

06 05 5 4

Lovett, John
Watercolor for the fun of it: getting started / John Lovett.--1st ed.
 p. cm.
Includes index.
ISBN 1-58180-192-0 (alk. paper)
 1. Watercolor painting--Technique. I. Title.
ND2420 .L68 2002
751.42'2--dc21 2001052159

Editor: Bethe Ferguson
Designer: Wendy Dunning
Layout Artist: Kathy Bergstrom
Production Coordinator: John Peavler

METRIC CONVERSION CHART

to convert	to	multiply by
Inches	Centimeters	2.54
Centimeters	Inches	0.4
Feet	Centimeters	30.5
Centimeters	Feet	0.03
Yards	Meters	0.9
Meters	Yards	1.1
Sq. Inches	Sq. Centimeters	6.45
Sq. Centimeters	Sq. Inches	0.16
Sq. Feet	Sq. Meters	0.09
Sq. Meters	Sq. Feet	10.8
Sq. Yards	Sq. Meters	0.8
Sq. Meters	Sq. Yards	1.2
Pounds	Kilograms	0.45
Kilograms	Pounds	2.2
Ounces	Grams	28.3
Grams	Ounces	0.035

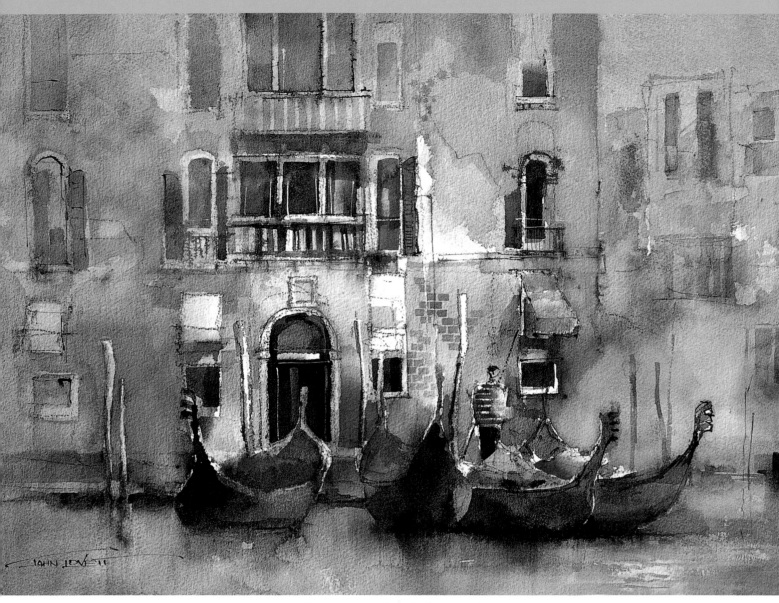

GONDOLAS • 14" × 20" (36cm × 51cm)

This book is dedicated to Dianne, Dane and Tim.

Table *of* Contents

1) discover PAPER

Learn how to choose the best paper and about varying textures, paper weight and sizing. You will learn how to prevent your paper from warping and buckling. Have fun and practice with two texture exercises and three step-by-step demonstrations.

page 12

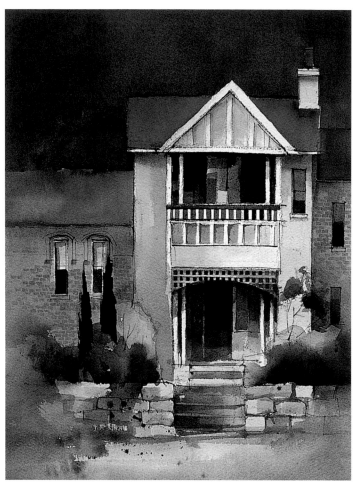

2) discover COLOR

Explore color theory lessons about choosing the best colors to start with—including the difference between transparent and opaque colors, the color wheel and arranging and mixing your colors. Follow along with two step-by-step demonstrations.

page 30

3) DISCOVER different ways to paint

Here you will learn about the best brushes for beginners and how pastel pencils can help you incorporate loose, sketchy lines into your watercolors. Includes eleven mini demonstrations that will show you how to create interesting textures and amazing results with household items, inks, masking fluid, gesso and gouache. You will also learn how techniques like sanding, scraping, lifting off, dropping in and pressing into wet paint can add fun and spectacular effects. Experiment with three step-by-step demonstrations. **page 44**

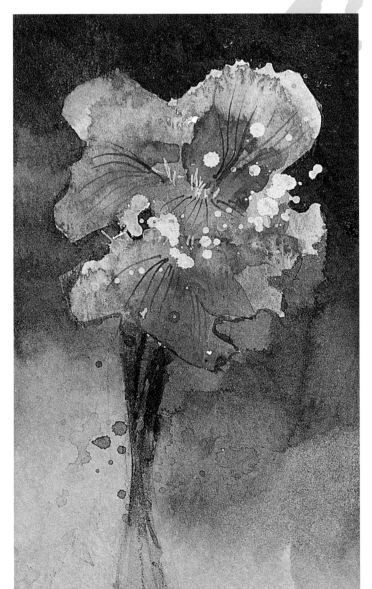

4) more easy TIPS &TRICKS

Learn how thumbnail sketches and other drawing tips can help you better design your painting before you begin—including using tonal values, a center of interest and color harmony. You will learn basic tips for painting specific subjects such as: trees, flowers, water, skies and buildings. Once you have mastered some of the basics of watercolor you can experiment with your own style. **page 74**

Introduction

When I was a little kid growing up in the 1950s, my dad would take me out on weekends to sketch and paint watercolors. He started painting as a teenager and it has been his livelihood for the past fifty years. I have watched my kids grow up with constant access to all the art materials in my studio, and it's a great pleasure to see their excitement as they create paintings from a palette full of rich, vibrant watercolors. It seems once you experience the fun of splashing these amazing colors over a big stretched sheet of beautiful white paper, you are hooked. ✿ The great thing about watercolor is that it doesn't take long to learn the tricks and secrets but, at the same time, it's a skill you can never master. The unpredictable, accidental nature of the medium makes you work with it rather than trying to control it. Part of the excitement of working with watercolor is that you never really know exactly what is going to happen. As you practice and progress, you will learn to trigger different "accidental" effects, and yet their results will always be a bit of a mystery. It is the excitement and challenge of working with these unpredictable events that makes watercolor such an addictive medium! ✿ Watercolor today has broken away from the narrow view held years ago that paintings had to be produced solely from transparent washes. The American Watercolor Society (AWS) accepts paintings in all water-based media including: watercolor, acrylic, gouache, casein and egg tempera. They draw the line only at collage and pastel. This book includes techniques—like rice paper collage, pastel and ink—that go beyond the traditional definition of watercolor. ✿ I will teach you how you can use simple household items to spark your creativity and liven up your paintings. These techniques mesh so beautifully with watercolor and have become such a major part of my work that it would be crazy to leave them out. ✿ So arm yourself with a few tubes of paint, some paper and a couple of brushes and let's have some fun!

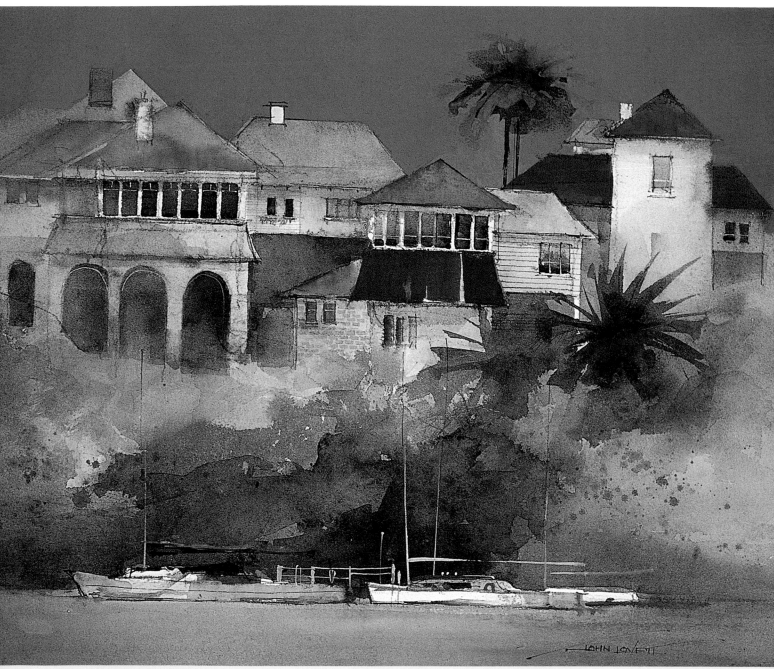

ABOVE THE BAY • 20" × 13" (51cm × 33cm)

A Quick Start Guide

GLOSSARY OF TERMS

Color wheel circular arrangement of the colors of the spectrum

Complementary colors opposites on the color wheel

Composition arrangement of lines, values, shapes, colors, etc. to create an artistic whole

Compound colors mixtures of the three primary colors

Contrast relationship of dissimilar elements in an artwork

Cool colors colors in which blue, green or violet predominate

Direction pattern of movement the eyes follow through a picture, controlled by lines, values, shapes, colors, etc.

Glaze a transparent layer of paint applied over a dry area allowing underpainting to show through

Hard edge a clean, clearly delineated edge or line between areas of a painting

Hue the spectral name of a color, such as red, orange, yellow, green, blue or violet

Lightfast resistant to fading upon long exposure to sunlight

Movement directional thrust that moves the eye across the surface of a painting

Opaque wash paint layer that covers the paper or other layers of paint and is not transparent

Primary colors colors you cannot mix from other colors: red, yellow and blue

Pure color pigment straight from the tube, not mixed with water or another color

Reflected color or light color or light reflected from one object to an adjacent object

Value the degree of lightness or darkness of a color

Saturated color vivid, concentrated color that is not mixed with water

Sedimentary colors containing fine particles that settle into the paper to create a texture

Soft edge blurry edge or line between areas of a painting, as when one wet color bleeds into another

Staining color a color that bonds to the paper, and is more difficult to lift or remove

Transparent wash thin paint layer that permits the white surface of the paper or another color to show through

Warm colors colors in which red, yellow and orange predominate

Your Basic Supply List

These are the minimum items you need to get started. Simply take your list with you to store and get ready to experiment!

The Best Papers to Start With

- 22" × 30" (56 cm × 76cm) 140-lb. (300gsm) Cotman or Arches cold-pressed watercolor paper
- 22" × 30" (56 cm × 76cm) 140-lb. (300gsm) Arches, Saunders or Fabriano rough watercolor paper
- 22" × 30" (56 cm × 76cm) 140-lb. (300gsm) Fabriano hot-pressed watercolor paper

The Best Brushes to Start With

- 1-inch (25mm) synthetic Taklon flat
- ¹/₄-inch (6mm) synthetic Taklon flat
- No. 2 synthetic Taklon rigger
- ³/₄-inch (19mm) bristle brush
- Large mop brush

The Best Paints to Start With

- Alizarin Crimson
- Aureolin
- Black acrylic or waterproof ink
- Burnt Sienna
- Cobalt Blue
- Ultramarine
- Phthalo Blue
- Quinacridone Gold or Indian Yellow
- Raw Sienna
- Rose Madder or Permanent Rose
- Scarlet Lake
- White gouache

The Best Palettes to Start With

- White palette with a large mixing area and at least ten wells, each well larger than 1" × 1" (3cm × 3cm)
- Old white plate for mixing gouache

Other Supplies

- Brown pastel pencil
- Cutting mat
- Gummed paper tape (adhesive paper)
- Large, plastic bowl or bucket
- Metal straight edge
- Paper for sketching
- Pencil
- Spray bottle
- Tissue or paper towels
- Waterproof plywood board

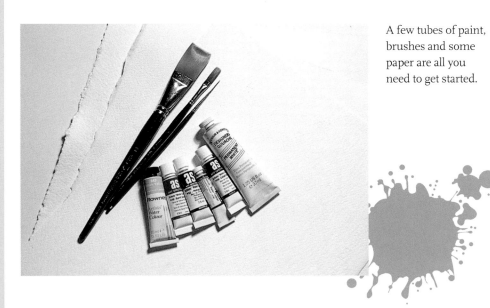

A few tubes of paint, brushes and some paper are all you need to get started.

Basic Techniques

FLAT WASH—a technique for covering an area with flat, even color. Start by wetting only the area to be covered with clean water. In a mixing dish, create a solution of enough paint and water to more than cover the area. Slightly slope your board toward you and apply the mixture in horizontal strokes from one side of the area to the other. Each stroke should just touch the one above. When you reach the bottom of the area to be covered, dry your brush and blot up any remaining beads of paint. You should finish with a nice even covering. Don't be tempted to go back and fiddle!

GRADED WASH— similar to a flat wash except the color gradually fades to white paper across the area to be covered. Apply this wash in a similar manner to a flat wash, but dilute the paint mixture slightly with each stroke.

WET-IN-WET—a technique that produces very soft, feathery shapes. It is generally used prior to dry-brush techniques, because definition and detail are difficult to achieve with wet-in-wet. The technique requires the paper to be thoroughly saturated—although the surface water can be blotted off with a clean towel—before starting the painting. No hard edges appear at first, but as the paper dries, sharper lines and more detail can be introduced. Apply this technique to the whole painting or just to selected areas.

WET-ON-DRY—a technique using a fully-loaded brush on dry paper. This produces a solid, flat, hard-edged shape. This brush-stroke can be modified by techniques such as feathering, dropping in and lifting off, which you will learn in chapter three.

DRY-BRUSH—the process of applying paint from a partially-loaded brush to dry paper. The resulting marks appear broken and textured. The rougher the paper, the more noticeable the texture.

1 discover PAPER

Walking into your local art supply store and trying to decide which sheet of paper best suits your needs can be confusing, even frightening. There seems to be a secret language spoken by people who "know about paper." Don't be put off though; the language is easy to learn. ⑤ By the end of this chapter, phrases like hot-pressed, cold-pressed, internally-sized, gsm and all those other strange-sounding terms will be part of your vocabulary! Armed with this knowledge you will be able to select the best paper for each of your paintings.

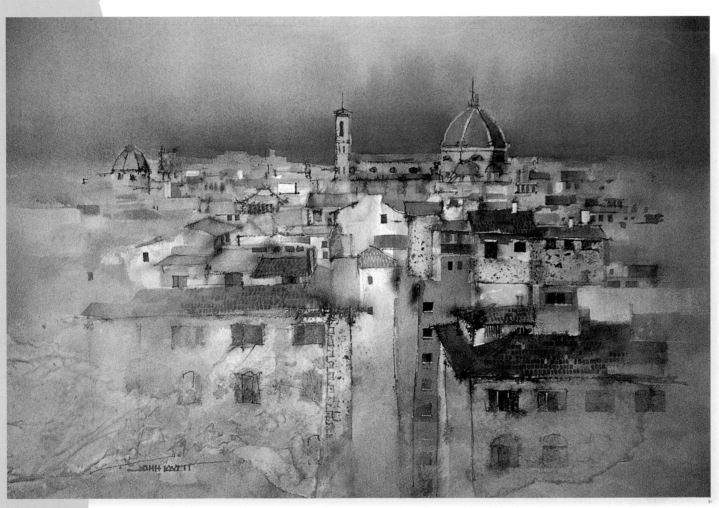

For this painting I glued three types of Japanese rice paper to Arches 140-lb (300gsm) rough, creating a suitable surface for this heavily textured subject.

ACROSS THE ROOFTOPS • 22" × 15" (56cm × 38cm)

Begin *with the* Basics: Paper

The secret to success when painting with watercolor is choosing high-quality paper. Make sure it is not too thin. (We will discuss paper weight later, but 140-lb [300gsm] is a good weight to start.) Don't buy cheap paper because you consider yourself a beginner. A top-quality paper such as Arches, Saunders or Fabriano is much more forgiving than cheap paper. On good-quality paper washes are much easier to control, paint can be washed back without a problem and buckling and cockling is much less likely to occur. If you want to save money on paper when you begin to paint, cut large sheets of good paper into eight pieces and do some quick, small paintings to get used to the paper.

Cotman paper, made by Winsor & Newton, is an inexpensive paper that gives good results. It is moderately textured and very white, giving nice bright colors and plenty of tonal contrast. Cotman paper is heavily sized, meaning the paint tends to sit on the surface. This is an advantage when you want to lift paint off, but causes large washes to be blotchy and uneven. For small paintings, up to 11" × 14" (28cm × 36cm), it is very good; for anything larger use a better-quality paper—my favorite is Arches rough 140-lb. (300gsm).

All paper behaves differently, so it is a good idea to experiment with a few different types to see which ones you like best. Start with two sheets of 140-lb. (330gsm) Cotman and either Arches or Saunders 140-lb. (300gsm) rough. You could try some or all of the basic techniques from page 11 on each of the papers. This will help you get the feel of each paper before you began any projects.

Watercolor paper comes in a many varieties of textures, weights, thicknesses and colors. Each one has its own unique qualities.

Arches paper has a finish that allows washes to blend and flow beautifully.

Pigment on Cotman paper can be washed back or lifted off easily .

Texture

Describing the surface quality of watercolor paper could be done simply with words like smooth, rough and very rough. Unfortunately we have to cope with a strange vocabulary that seems to have little to do with texture! Hot-pressed, cold-pressed, NOT (see explanation below) and rough are the terms used to describe paper texture. The easiest way to remember what they mean is to use an ironing analogy. Using a hot iron (hot-pressed) will give a smooth flat finish. A cold iron (cold-pressed) will NOT be as smooth. Rough is self explanatory.

Hot-pressed (HP) paper has a smooth, flat surface and is best suited to fine detailed paintings. Miniature paintings in particular benefit from its fine-grained texture.

Cold-pressed (CP) paper is sometimes called NOT or FIN, and is by far the most popular type of watercolor paper. It has a moderately rough texture and allows certain pigments to form wonderful sedimentary textures as they settle into depressions in the paper.

Rough paper is just that—rough! The boundary between cold-pressed and rough is fairly blurred, but there is no mistaking some of the extremely rough papers. Filled with deep depressions, ridges and valleys, some of these papers appear to have been run over on a gravel road. They can give excellent results, but must be carefully matched to the subject so as not to overwhelm it. A rough, choppy ocean or heavily textured stone wall would work well on this type of paper, but a soft landscape or sensitive portrait would become lost in the texture.

Watercolor Blocks

Most paper manufacturers produce watercolor blocks containing their most popular papers. If you find a paper you enjoy using and don't wish to work on full sheets, blocks are a convenient option. Paper in watercolor blocks is already stretched and mounted, ready for painting. These blocks come in a number of sizes and weights and are ideal for traveling. The only downside is the fact that you can't work on more than one painting at a time. Make sure your paintings are completely dry before you remove them from the block, otherwise they will buckle when they dry. A small pocketknife is handy for removing paintings from the block. Insert it in the opening (usually at the top of the block) and carefully run it around the outside.

Paper Weight

There are two common methods of classifying paper according to weight. The European system uses the grams per square meter or gsm method. This simply means that paper labeled as 300gsm,

measuring 1m × 1m, would weigh 300 grams. The American system lists the weight of the paper per ream, or 500 sheets. If the paper is describes as 140-lb. paper, that is the weight of a ream.

Watercolor paper ranges in weight from 10-lb. (150gsm) to around 420-lb. (900gsm). The lighter weight papers (under 140-lb. or 300gsm) are best suited to sketching or smaller work. Heavier paper tends to act a bit like blotting paper and can suck the intensity out of colors. It is best suited to large wet washes and wet-in-wet techniques.

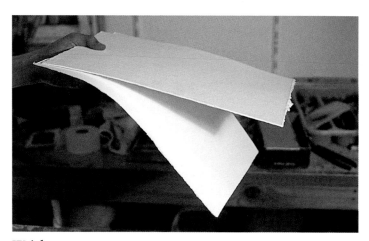

Weight
Watercolor paper varies in weight from thin, lightweight sheets to heavy, handmade paper approaching the thickness of cardboard.

Sizing

To control the absorbency of paper, manufacturers add gelatin-based sizing to the paper pulp mixture along with fungicides and various other chemicals. This is referred to as internal sizing. After the paper pulp has been made into individual sheets, external sizing is applied. This involves dipping the finished sheets into a tub of size before final drying.

The balance between internal and external sizing has a huge effect on the behavior of watercolor paper. Paper with no sizing at all is very absorbent and tends to lighten dark tones as they dry. Color intensity is also reduced with this type of paper. Heavy external sizing causes pigment to sit on the surface, giving good color intensity, but making smooth, even washes difficult to produce. Paper manufacturers closely guard the amount and type of sizing they use to produce various characteristics in their papers.

Declare War *on* Warping

Thin watercolor papers can warp or buckle while you are painting. Stretching your paper before you begin can prevent hassles later on. It is a good idea to stretch any sheet of paper larger than 11" × 14" (28cm × 36cm). Some people like to soak paper in water, stretch it over a solid board and secure it with staples or thumbtacks. This stretches the paper effectively, but it is time consuming and unnecessary unless you work very wet. I find spraying the paper and taping it down will help maintain the shape.

[MATERIALS LIST]

- Watercolor paper
- Metal right angle
- Pencil
- Spray bottle
- Gummed paper tape (adhesive tape)
- Waterproof plywood board (for taping wet paper to)

1" × 1½"(3cm × 4cm) timber

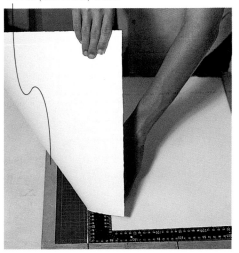

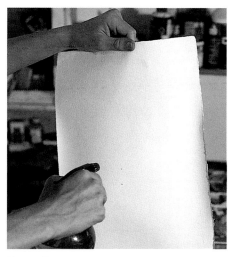

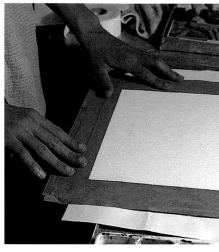

Tear It
You can cut your paper with a craft knife, but tearing produces a more interesting edge. A metal right angle and cutting board are handy tools. The right angle can be picked up at your local hardware store. You can make a cutting board by gluing and tacking two pieces of 1" × 1½" (3cm × 4cm) plywood at a right angle. Mark points a quarter of the way and halfway on the plywood strips to makes it easy to cut and tear your paper accurately with the aid of the metal angle. Make a nice, clean tear by keeping firm pressure down the steel right angle and tearing the paper back across the steel.

Spray It
Use a spray bottle to wet your paper. Make it fairly wet, then spread it out on a board to absorb the water for a few minutes. The paper will probably buckle a little as it swells so smooth it out flat before moving on to the next step.

Tape It
After the paper has set for a couple of minutes, it will have absorbed water and swollen slightly. Tear off four strips of gummed paper tape. Wet each strip with a couple of light sprays and tape the paper to your backing board. Lay your paper flat and allow it to dry evenly. Once the paper is dry, it will shrink back to its original size and provide a nice, tight surface to work on.

Tip Before cutting your paper, find the watermark by holding it up to the light. Turn the paper so the watermark is readable. Place a small x in each corner. After the paper is cut, each piece will have an x to tell you which side is the front.

Tip Waterproof plywood is the best wood to tape your paper on. If you use a composition board or compressed fiberboard, give it two or three coats of gesso. The acid residue from the glue used in manufacturing can leach into your paper if the board is not sealed.

Build it Brick by Brick

In this exercise the underlying texture of paper provides an interesting surface, reinforcing the texture of the brick wall. These techniques are especially handy for many of your paintings of buildings.

[MATERIALS LIST]

Paints
- Alizarin Crimson
- Burnt Sienna
- Raw Sienna
- Ultramarine

Brushes
- 1-inch (25mm) flat Taklon
- no. 2 Taklon rigger
- ¼-inch (6mm) flat Taklon

Paper
- 140-lb. (300gsm) Arches CP

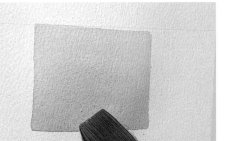

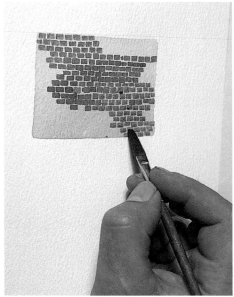

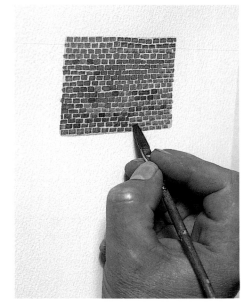

1 | **Begin with a Background Wash**
Begin by creating the illusion of the mortar joints between the bricks using your 1-inch (25mm) flat and a pale wash of Raw Sienna. Be as scruffy and uneven as you wish. I was a little too careful here—a more uneven finish would have provided greater interest. Allow this wash to dry before moving on to the next step.

2 | **Lay in the Bricks**
Start laying in the bricks carefully with Burnt Sienna and your ¼-inch (6mm) flat. Make sure to stagger the vertical joints and keep the rows straight. Don't worry if the sizes and shapes of the bricks vary slightly. This will make the wall more interesting.

3 | **Mix it Up**
Once all the bricks are in place, go back and vary the color of some of them slightly. Mix Ultramarine into some of the Burnt Sienna bricks to make a few cool dark bricks. Place them randomly and unevenly throughout the wall. Insert a couple of random Alizarin Crimson bricks to increase variety.

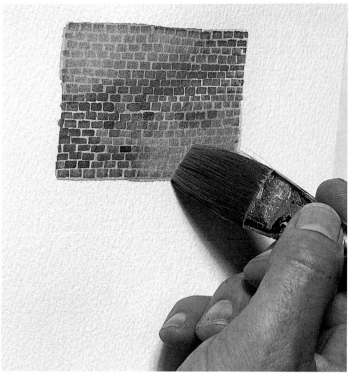

Shift the Focus

4 | With your 1-inch (25mm) flat and some clean water, slightly dissolve an area of bricks by dragging the brush diagonally. Completely wash away some of the bricks, and leave others visible but subdued. Try washing away opposite corners of your brick wall. You will bring these soft areas back into focus in the next step, giving the wall a complex, interesting texture.

It's the Little Things that Count

5 | Using your rigger brush, loosely detail the mortar joints in the washed out corners with a mixture of Burnt Sienna and Ultramarine. This will help shift them from light to dark.

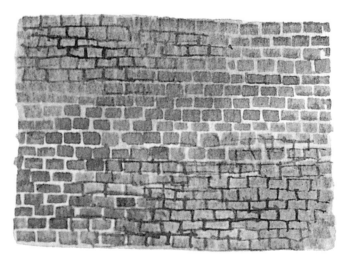

Finished Exercise

The shift from light to dark in the mortar joints—and the variation in size, tonal value and color in the bricks—adds life and character to this little piece of wall.

Roughing It

In this exercise you will learn techniques to help you replicate the interesting texture of an old stone wall. You can create a diagonal pathway through your painting to take advantage of the heavily textured paper and add interest.

[MATERIALS LIST]

Paints
- Burnt Sienna
- Raw Sienna
- Ultramarine

Brushes
- 1-inch (25mm) flat Taklon
- No. 2 Taklon rigger
- ¼-inch (6mm) flat Taklon
- old ¾-inch (19mm) bristle brush

Paper
- 140-lb.(300gsm) Fabriano rough

Other Supplies
- Tissue

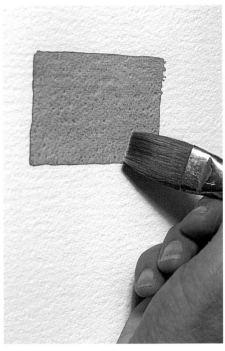

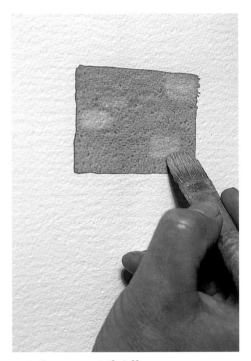

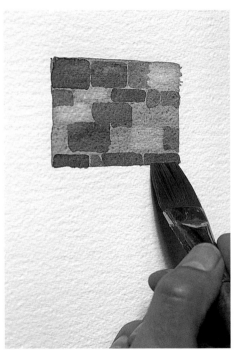

1 | **Begin with a Background Wash**
Wash in a rectangle for the background of this exercise with a mixture of Raw Sienna, Burnt Sienna and Ultramarine. Make it a fairly wet mix so some of the pigment can float and some can settle into the texture of the rough paper. It is not necessary for this wash to be flat and even, so don't worry if it looks a bit patchy.

2 | **3… 2… 1… Lift Off**
This is where an old bristle brush is handy. It will do a better job than your 1-inch (25mm) flat and you won't damage your good brush. Dampen and rub three or four stone shapes out of your background wash. Lift off the pigment with a tissue as your bristle brush dissolves it. Don't forget to vary the size and shape of the stones you lift out.

3 | **Harmonizing with Color**
Using your 1-inch (25mm) flat and mixtures of Burnt Sienna and Ultramarine, vary the colors and shapes of your stones from a pure Burnt Sienna to a cool gray. This will introduce variety while maintaining color harmony.

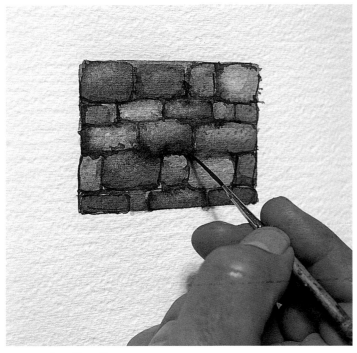

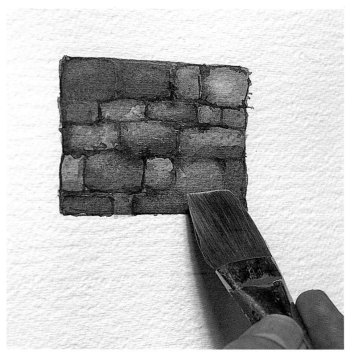

4 | **Define Your Stones**

Make a dark mixture of Burnt Sienna and Ultramarine. Using this mixture and your rigger, apply some dark lines to the joints between the stones. Quickly feather them into shadows on the lower edges of the stones using your damp ¹/₄-inch (6mm) flat. Work over the entire surface, gradually introducing sharper lines. Still using your damp ¹/₄-inch (6mm) flat, lift some of the pigment off the tops of some of the larger shapes to give the stones a nice, solid appearance.

5 | **Visualize the Path**

This exercise could be left alone now, but to make it more visually satisfying, some areas of relief should be added. Create a diagonal pathway through the painting by washing out some of the detail in the upper left and lower right corners with your damp 1-inch (25mm) flat. Reduce the detail by putting a pale wash of cool gray over these corners. You will use this diagonal movement through the finished painting of a stone wall on pages 27-29.

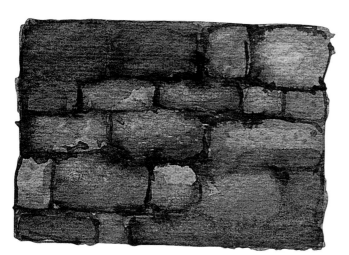

Finished Exercise

The texture of rough paper enhances the visual character of the stones.

Fishing for Details

This smooth paper gives you the opportunity to include as much detail as you wish. It also allows you to create visual textures rather than letting the underlying paper texture dictate the surface character. A small thumbnail sketch gives you a chance to shuffle your background details before you begin painting.

[MATERIALS LIST]

Paints
- Alizarin Crimson
- Permanent Rose
- Phthalo Blue
- Quinacridone Gold
- Ultramarine

Brushes
- 1-inch (25mm) flat Taklon
- No. 2 Taklon rigger
- ¼-inch (6mm) flat Taklon

Paper
- 140-lb. (300gsm) Fabriano HP

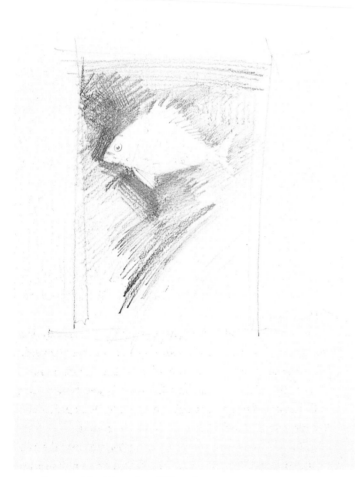

1 **Begin with a Thumbnail Sketch**
This little sketch shows the zig-zag thrust leading the eye up to the center of interest. Keep the strongest value next to the white head to create an obvious center of interest.

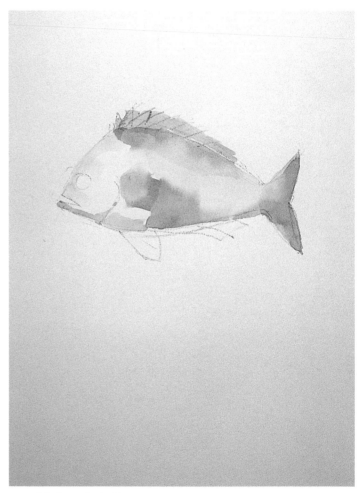

2 **Wash on the Fish**
Draw the fish's profile; don't worry about detail in your drawing, that can be added later. Wet the body of the fish with your 1-inch (25mm) flat or a large mop brush. Mix some Phthalo Blue, Ultramarine and Alizarin Crimson. Paint the mixture on the tail and underside of the fish slightly mauve using more Ultramarine and Alizarin Crimson. Use more Phthalo Blue at the top of the fish. The colors should bleed and mix. Don't worry about accuracy at this stage.

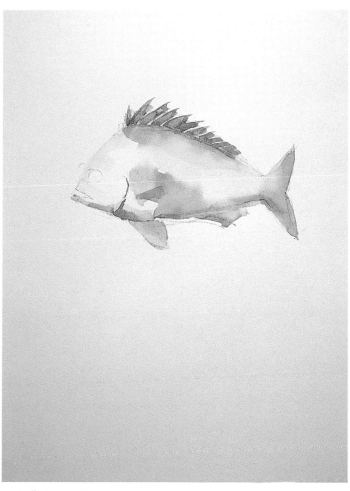

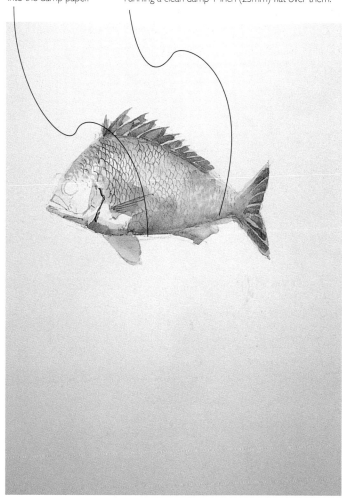

Let these soft scale shapes bleed and feather into the damp paper.

Paint these soft scales with your ¼-inch (6mm) flat brush, and then before they dry, soften them by gently running a clean damp 1-inch (25mm) flat over them.

3 | **Spike the Interest**

Paint the shapes of the lower fins using your ¼-inch (6mm) flat and a wash of Quinacridone Gold. While the fins are still wet, add some pale gray to make them more interesting. Paint the top fin with a green-gray mixture of Phthalo Blue, Ultramarine, Quinacridone Gold and Alizarin Crimson using your ¼-inch (6mm) flat. Leave small gaps for the bones in the top fin. Deepen the shadow on the fish's belly with the same color.

4 | **Scale it Back**

Draw in the elongated scale shapes across the fish's body with the green-gray mixture and your rigger brush. Paint detailed, accurate scales toward the front of the fish and loose details toward the tail. While you have this color in your brush, add a little more definition to the gills and mouth. Add detail to the tail with your ¼-inch (6mm) flat and this mixture.

With a clean 1-inch (25mm) flat, wet the area near the tail. Paint some small scales on the damp area with your ¼-inch (6mm) flat and a mauve-gray mix of Ultramarine and Alizarin Crimson, subdued with a little Quinacridone Gold.

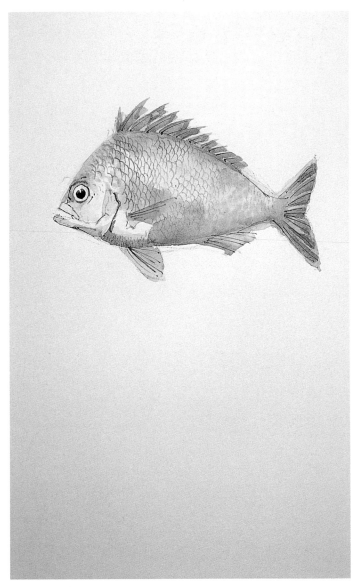

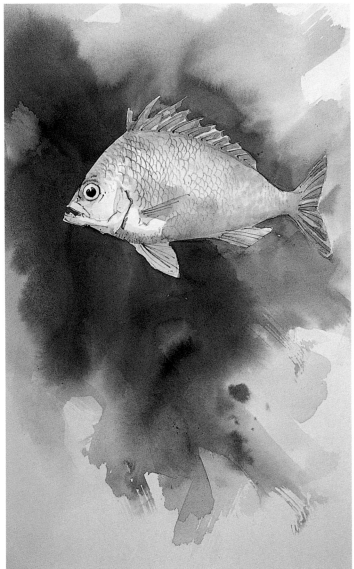

5 **Head for the Details**

Mix a dark blue-gray with Ultramarine, Quinacridone Gold and Alizarin Crimson and carefully paint the pupil in the fish's eye with your rigger brush. Leave a small patch of light at the top to keep the pupil from looking dead and neutral. While the pupil is still wet, drop in pure Ultramarine with the tip of your rigger. Using the same dark color as for the pupil, draw some fine dark lines to suggest detail around the mouth, gills and eye. While you're at it, flick a few thin lines into the fins and tail. By now your fish should be starting to come to life!

6 **Just Add Water**

The secret to the success of this painting is to establish strong tonal contrast around the fish's head for your center of interest. Movement away from this area will distract the eye flow and make the work confusing. Wet the entire background area with clean water, carefully cutting in close around the fish. Mix a dark wash of Phthalo Blue and Quinacridone Gold on a clean area of your palette. Flood it loosely through the background with your 1-inch (25mm) flat. Concentrate the darkest area of the wash around the head, and feather it out as you move toward the outside of the painting. Try to avoid hard edges and keep the diagonal zig-zag from the thumbnail in mind as you push the wash around.

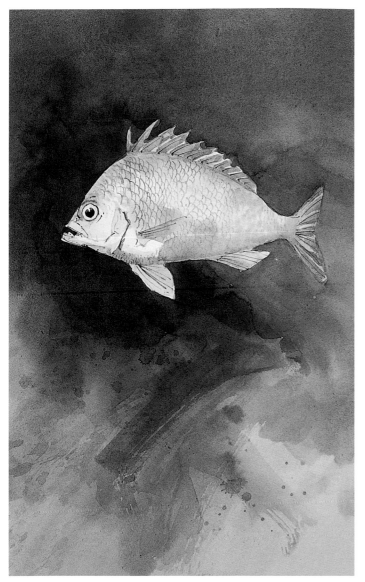

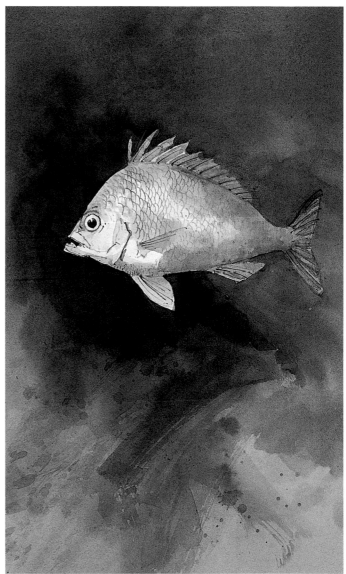

7 | You're Getting Deeper

To get tonal depth on hot-pressed paper, washes have to be built up layer upon layer. Wash Ultramarine over the top region of the background down to the fish. While this is still wet, flood in an extremely dark mix of Alizarin Crimson and Phthalo Blue around the head, working it down around the bottom fin and into the zig-zag leading up to the fish.

Tip When painting the background, don't make it so busy that it distracts from the center of interest. There should be enough happening to maintain interest and guide the eye to the focal point without causing distraction or confusion. Remember, keep it broad and wet, and use the biggest brush possible.

8 | Fuse Your Fish

By now your painting should look pretty close to being finished. Sometimes paintings look like an object has been cut out and pasted on when the subject is surrounded by a dark background. To prevent this, allow parts of the background to blend with the subject. Also introduce more of the background color into the subject to help fuse them. Use your 1-inch (25mm) flat to dampen the tail and belly of the fish. Then carefully wash in a diluted Phthalo Blue. Keep an eye on the edges. If they start to form hard lines, feather them with your clean, damp 1-inch (25mm) flat. Allow the edge of the fish to bleed and blend with the background. With your rigger brush and some pure Phthalo Blue, draw a few fine lines into the tail and fins to further tie the subject to the background.

This Old House

This painting was done from a sketch of an interesting old house. This exercise will allow you to take advantage of the texture of cold-pressed paper, in which the sedimentary colors settle into the grain of the paper. The Arches sizing allows the wet washes of the bushes to merge and blend into wonderful unpredictable patterns. Complementary colors—warm orange and Ultramarine—give this painting life and impact. Simple areas of relief in the roof and sky balance areas of sharp detail around the door. The contrast between loose, abstract shapes in the bushes and foreground and the focused details in the building give a much more interesting result than sharp, intricate details used in the entire painting.

[MATERIALS LIST]

Paints
- Alizarin Crimson
- Burnt Sienna
- Phthalo Blue
- Quinacridone Gold
- Raw Sienna
- Scarlet Lake
- Ultramarine

Brushes
- 1-inch (25mm) flat Taklon
- No. 2 Taklon rigger
- ¼-inch (6mm) flat Taklon

Paper
- 140-lb.(300gsm) Fabriano CP

Other Supplies
- Neutral-colored pastel pencil

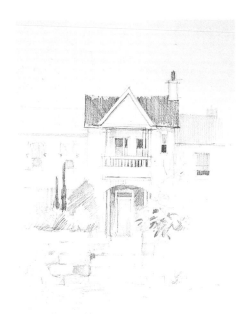

1 | **Begin with a Thumbnail Sketch**
The basis for this painting is a loose pencil sketch of the stone steps leading up to an interesting old building. Because there is no color information, we can take an exaggerated approach to what we imagine the building might look like. Loosely sketch in the major shapes of the composition. Make the shapes accurate but don't worry about detail at this stage. Use a neutral-colored pastel pencil so some of the drawing lines can remain as part of the finished work.

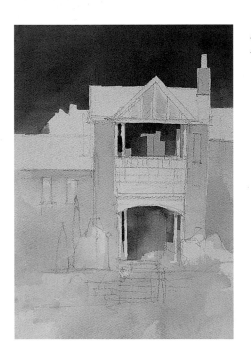

2 | **Initialize the Wash**
Start by washing a mixture of Burnt Sienna and Quinacridone Gold into the foreground and walls of the building with your 1-inch (25mm) flat. You can vary the tones slightly by changing the concentration of the mixture for the different areas. For instance, apply the most diluted mix first, then add a more concentrated solution without worrying about those strange cauliflower shapes—sometimes called blooms—which are caused by two fluid areas merging, creating an unusual texture. While this dries, wet the sky with your 1-inch (25mm) flat and cover the sky with a strong wash of Ultramarine. After the first wash has dried, add some shadows to the verandas with a mixture of Burnt Sienna, Quinacridone Gold and Ultramarine.

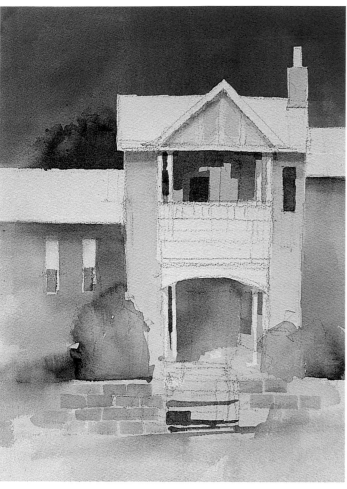

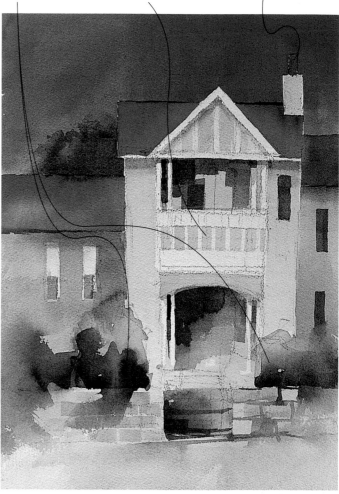

Don't be too fussy or careful with these shapes. Get them on quickly before they dry and drop in some pure Burnt Sienna.

These shapes can be applied with your -inch (25mm) brush and a mixture of Quinacridone Gold and Burnt Sienna.

Add some Burnt Sienna to the orange roof mix and paint the chimney pot.

3 | **Define Your House**

Continue to use your 1-inch (25mm) flat and the same three colors to suggest some stones in the foreground wall. Vary the color slightly for interest. Add some more Quinacridone Gold and a small amount of Phthalo Blue to the mixture and wash in the areas of foliage. Be loose and rough. While the paint is still wet, introduce a more concentrated mix of Burnt Sienna and Phthalo Blue to the underside of the bushes to indicate shadows.

Mix a cool mauve-gray with Alizarin Crimson and Ultramarine and gray it slightly with some Quinacridone Gold. Use this mixture to darken the windows and put shadows on the stairs and under the eaves. Wash some of this color over the outer walls to push them back.

4 | **Simply Terra-Cotta**

Mix some Scarlet Lake and Quinacridone Gold into the richest, strongest orange you can produce. Paint the roof areas with your 1-inch (25mm) flat, making sure to keep all the corners sharp and square. While the paint is still wet, drop a small amount of pure Alizarin Crimson into the top left of the roof to vary the color slightly. You can work some Phthalo Blue and Burnt Sienna into the foreground bushes, steps and doorway to increase contrast and depth. Add some windows to the right-hand facade and some detail to the stone wall using Burnt Sienna and Ultramarine.

Indicate the holes in the lattice with your Ultramarine and Burnt Sienna mix and your ¼-inch (6mm) flat. Be careful to line them up both vertically and horizontally. Some light pencil lines will make this easier.

If your Ultramarine sky is not flat and even, you can put another wash over the entire area once everything is thoroughly dry.

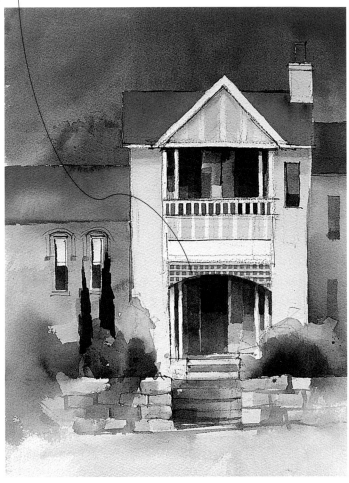

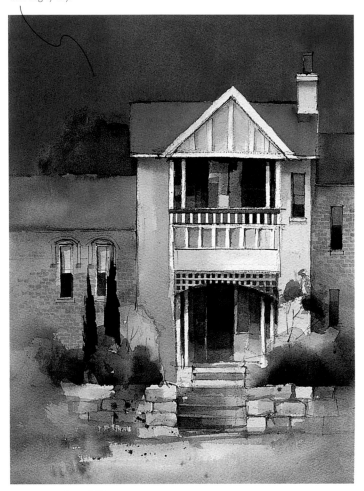

5 | **Build in the Details**

Mix a dark pool of Ultramarine and Burnt Sienna. With your 1-inch (25mm) flat, darken and sharpen the detail under the verandas. Use your ¼-inch (6mm) flat to add the openings in the top veranda railing and your rigger brush to add some linear detail to the stairs, windows and main building. Put in the thin pine trees with the edge of your 1-inch (25mm) flat and a mixture of Phthalo Blue and Burnt Sienna. Paint the dark bush on the right with the same color. Feather the top edge before it dries by washing out your 1-inch (25mm) flat and running a damp area around the top of the bush for the paint to bleed out into.

6 | **Finish it Off**

Clean a spot on your palette and mix a cool gray wash with Ultramarine and a little Burnt Sienna. Flood the mixture into the foreground and feather out the top edge with a damp 1-inch (25mm) flat. Grade the same color on the left-hand section of the main building to push it back behind the foreground bushes. Add some Alizarin Crimson to this gray mixture and splash it loosely into the left-hand corner, concentrating the light in the foreground at the foot of the stairs. Mix a stronger version of this color for the handrail on the top veranda.

Using your ¼-inch (6mm) flat put stones into the walls, varying them slightly as you did in the exercise on page 18. All you need to do now is add some more definition with your rigger brush and a dark mixture of Burnt Sienna and Ultramarine. Define the lattice, some windowsills, the veranda, the gable and a few fine twigs in the garden. Remember to keep the lines thin and confident!

Doorway to Discovery

This weathered timber door in the side of an old stone building makes a great subject for rough paper. The paper's surface enhances the random, stippled texture of the stone and the splintery appearance of the door. In this exercise you will learn to make a painting more intriguing by losing detail.

[MATERIALS LIST]

Paints
- Alizarin Crimson
- Burnt Sienna
- Quinacridone Gold
- Raw Sienna
- Ultramarine

Brushes
- 1-inch (25mm) flat Taklon
- No. 2 Taklon rigger
- ¼-inch (6mm) flat Taklon

Paper
- 140-lb. (300gsm) Fabriano rough

Other Supplies
- Brown pastel pencil
- Soft lead pencil (4B or 5B)

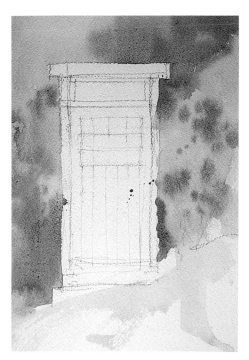

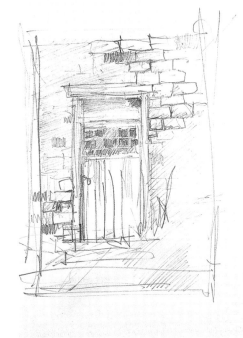

1 | **Begin with a Rough Thumbnail Sketch**
Before starting to paint, spend two or three minutes shuffling your ideas around with a soft lead pencil (4B or 5B). Establish the center of interest and place the maximum tonal contrast (e.g. light vs dark) there. A small thumbnail sketch will enable you to juggle your subject into an interesting composition and work out the tones for the various shapes that will make up your painting. I have decided to make the broken glass in the top window the center of interest and to establish a strong diagonal movement through the painting. This will offset the symmetrical, static nature of the subject.

2 | **Sketch and Splash**
Roughly sketch in the shapes of the door and windows with a brown pastel pencil. Add a few light lines to suggest mortar joints between the stones. Concentrate these around the lower left and upper right corners of the door opening to aid the diagonal movement. Some of these pastel pencil lines can remain as part of the finished work.

Mix a pale, watery wash of Raw Sienna and flood it over the entire painting, except for the door. Don't be too precise and don't worry if the whole area is not covered. Mix a little Ultramarine and Burnt Sienna into the puddle of Raw Sienna left on your palette. Splash, pour, squeeze or drop this mixture into the still wet Raw Sienna on your paper. Repeat this splashing and pouring process with a couple varied combinations of these colors. Don't be fussy and don't worry if it appears to be a bit of a mess. The colors will bleed and settle, taking advantage of the rough texture of the paper. Watch as this wash dries and with a damp 1-inch (25mm) flat soften any hard edges that appear. Carefully run the brush along the edge once or twice to feather out the hard edge. Don't overdo it or you will lift off paint.

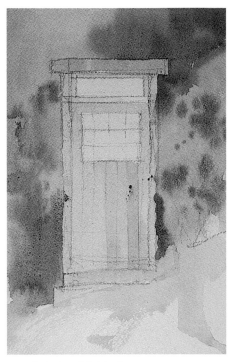

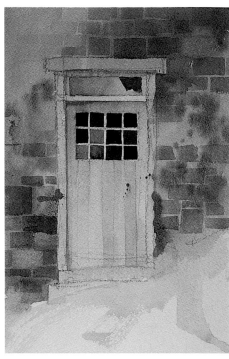

3 | Weather Me Timbers

Wash a watery mixture of Ultramarine and Burnt Sienna over the door and doorframe with your 1-inch (25mm) flat. When this wash is almost dry, use a clean, damp 1-inch (25mm) flat to lift pigment out of some of the vertical boards. Adding variety like this makes the surface much more interesting. Color variety can be introduced with a light wash of Burnt Sienna over one or two of the boards.

4 | Building the Wall

This is where you can have great fun with your 1-inch (25mm) flat. Using various combinations of Burnt Sienna, Ultramarine and Quinacridone Gold, emphasize a few stone shapes. Be careful to stagger the vertical joints and vary the sizes and shapes. Make some of your stones slightly warm while including a few contrasting cooler ones to add interest. Emphasize the diagonal movement through the painting by making the stones more detailed and defined around the bottom left and top right of the door.

5 | Establish Your Center

Now comes the exciting part—adding some dark accents! Mix a cool, dark combination of Ultramarine, Alizarin Crimson and Burnt Sienna; use plenty of paint and only a little water. Using your 1/4-inch (6mm) flat, carefully paint the square windowpanes. Slightly vary the tone and color of each square to keep the panes from becoming monotones.

When the painting has dried add the shadows around the door frame and upper window with your 1/4-inch (6mm) flat and a pale mixture of Ultramarine and Burnt Sienna, leaning more toward blue. Soften the edge of the shadows with your clean, damp 1-inch (25mm) flat. Paint the small areas one at a time so you can soften the edges while the paint is still wet. Be sure to make this wash lighter toward the dark, broken section of glass to lead the eye back to the center of interest.

Tip Remember to hold your rigger brush upright and move your arm from the shoulder to produce fine and confident lines.

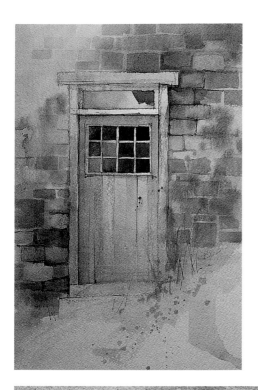

6 | Detail and Define

Use your rigger brush and a dark mixture of Burnt Sienna and Ultramarine to define the edges around the doorframe and windows. You only need to do a few fine, confident lines. Don't worry if they are not in exactly the right place. As well as suggesting detail, they add looseness to the painting.

Introduce detail and definition into the stones with the same fine lines, this time softening some with your clean, damp 1-inch (25mm) flat just after they are applied.

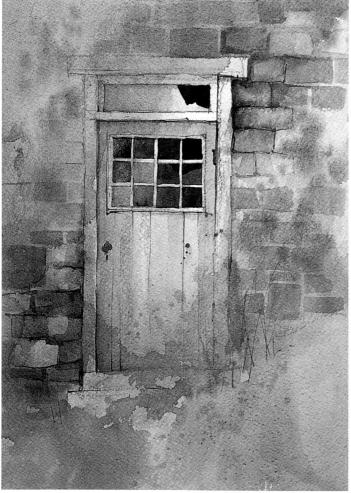

7 | Tell the Story

By now your painting should be starting to take shape. The temptation at this point might be to tidy up a few details and call it finished. Fight the urge, and let the looseness of the painting add mystery.

Mix a large watery puddle of Ultramarine and a little Burnt Sienna. Roughly and randomly flood the mix over the top left and bottom right-hand corners of the door using your 1-inch (25mm) flat. Soften any hard edges with a clean, damp 1-inch (25mm) flat before the wash dries. Place some patches of pure Alizarin Crimson into the mortar joints near the center of interest, and add a knob to the door. A hard-edged wash of Quinacridone Gold and Burnt Sienna splashed loosely into the foreground will help tie the wall to the ground. Drag a ¼-inch (6mm) flat dipped in pale gray and dried off slightly over some of the boards to bring out the texture of the rough paper.

Tip By losing some of the detail and encouraging the viewer to imagine what is missing, the painting becomes a little more mysterious. Thoughts turn to who broke the window, when the door was last opened and what's behind it. If every detail is sharp and focused, questions like these don't arise.

discover COLOR

Color can determine the mood of your paintings, make a statement and let your inner thoughts

take flight. ⑤ There are a handful of paints I consider indispensable; including one of the most important colors

for beginning watercolorists, a transparent yellow. Most yellows are opaque and tend to be sedimentary. You will

end up with mud if you try to mix dark values with these yellows, because the tone of the dark is lifted and

transparency is lost. There are two excellent strong, transparent yellows: Rowney's Indian Yellow and Winsor &

Newton's Quinacridone Gold. The Rowney brand is a clean, transparent Indian Yellow, and I have yet to come across

Quinacridone Gold made by any other company. ⑤ The other colors I cannot do without are Ultramarine,

Alizarin Crimson, Phthalo Blue and Burnt Sienna. For overglazing and building up transparent washes, Cobalt

Blue, Rose Madder (or Permanent Rose—a little pinker but more lightfast) and Aureolin are beautiful, transparent,

nonstaining pigments. ⑤ I also use White gouache. It can be tinted with watercolor pigments, applied as a thick

opaque layer or washed on as a thin, translucent glaze. A separate palette or an old plate is handy for mixing gouache.

If gouache mixes with transparent colors, it will pollute and muddy them. ⑤ I use the following colors occasionally:

Indigo, a dark, dirty blue; Winsor Red, a warm, staining red; and Winsor Yellow, a cool, opaque, staining yellow.

The impact of this painting comes from the stark contrast between the flat, opaque sky and the luminous, transparent roof. Combining transparent watercolor and opaque gouache in this way enhances the character of each type of pigment.

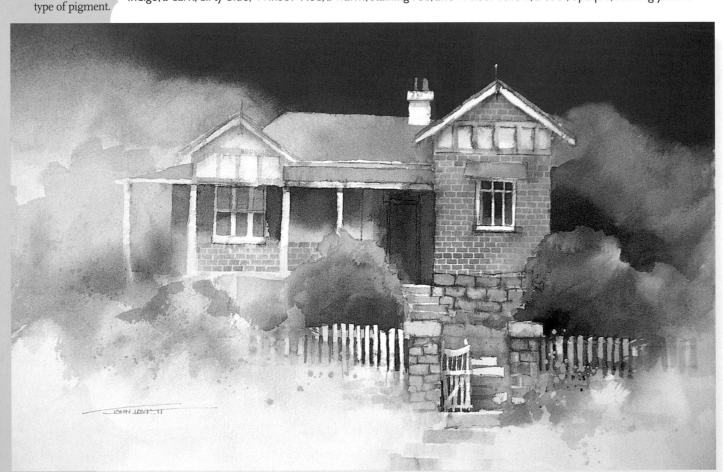

THROUGH THE GATE • 22" × 15" (38cm × 56cm)

Begin *with the* Basics: Paints

You don't need hundreds of tubes of paint to get started in watercolor. I generally only use six colors in most of my paintings.

INDIAN YELLOW—a clean, transparent, warm, staining yellow

QUINACRIDONE GOLD—a transparent brownish-yellow, less intense but more permanent than Indian Yellow

RAW SIENNA—a dirty, brownish-yellow sedimentary pigment, good for initial washes in many landscape-based paintings

ULTRAMARINE—a strong, warm, sedimentary blue

PHTHALO BLUE—an intense, cool, staining blue

ALIZARIN CRIMSON—a cool, transparent, staining red

BURNT SIENNA—a transparent reddish-brown

COBALT BLUE—a transparent, nonstaining blue

ROSE MADDER—a transparent, nonstaining red

AUREOLINE—a transparent, nonstaining yellow

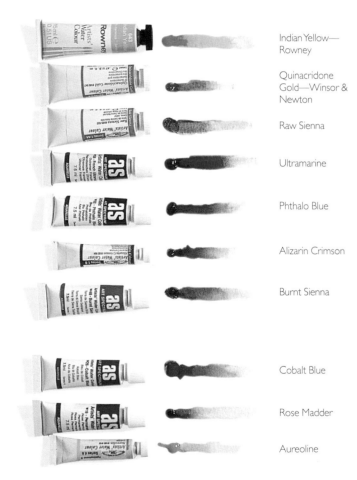

Indian Yellow—Rowney

Quinacridone Gold—Winsor & Newton

Raw Sienna

Ultramarine

Phthalo Blue

Alizarin Crimson

Burnt Sienna

Cobalt Blue

Rose Madder

Aureoline

Color Coding

Traditionally, watercolor has been done by building transparent washes layer upon layer. This technique certainly produces beautiful, luminous paintings, but the introduction of contrasting opaque pigments can really put some life and power into your work.

Squeeze some paint onto your palette, mix it with water and apply it to your paper. The first thing you'll notice is the hue or color of the pigment. Not quite so obvious, but very important to the color's behavior is the pigment's physical nature. Some paints are strong stains, some are opaque, some are gritty and sedimentary and others are very soft and transparent.

There is a simple test to discover which colors stain, are transparent or are opaque (look back on page 10 for definitions). Paint a line of each color across a black stripe of acrylic or waterproof ink. When the paint is dry, mask off all but a small section of the colored lines and wash them off with a brush and clean water. This will reveal which colors stain—some will wash off completely while others will hardly change. Where the lines of pigment cross the black stripe, opaque colors will appear to sit on the surface and transparent colors will seem to disappear behind the line.

You will soon discover that staining colors are incredibly strong, difficult to wash back (tone down) and tend to bleed up through any washes placed over them. Transparent stains make wonderful, rich, dark colors.

Transparent, nonstaining colors are clear and subtle and can be washed back easily. You can build them up without disturbing the underlying washes. They are useless for mixing dark colors but great for warming up or cooling down areas of a painting. A wash of Rose Madder over a foreground will warm it and bring it forward without obscuring any detail. Similarly, Cobalt Blue can be washed over parts of a painting to shift those areas into the background.

Opaque and sedimentary colors can combine and settle into the grain of the paper to produce interesting textures and patterns. You can wash them back fully, but they don't work in multilayered washes. Once three or four washes of sedimentary pigment have been applied, the grain of the paper will become full of pigment and the underlying washes will break down with each new application.

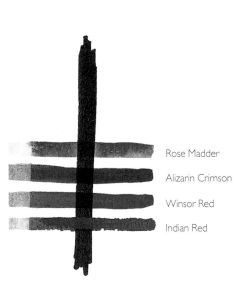

Rose Madder

Alizarin Crimson

Winsor Red

Indian Red

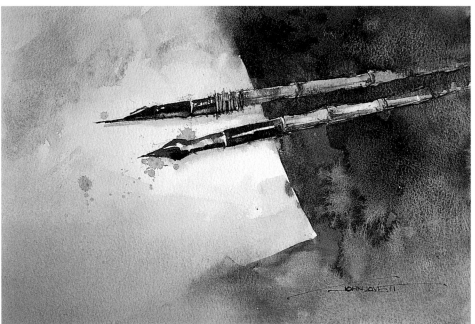

This test shows the transparency or opacity and staining ability of four reds: Rose Madder, Alizarin Crimson, Winsor Red and Indian Red. Notice the opacity of the Indian Red where it crosses the black line. Compare the staining ability of the Alizarin Crimson and Winsor Red to the Rose Madder, which washed almost completely away. It is a good idea to perform this test with all of your colors and keep it as a handy reference.

In this painting, you can see the difference in pigment types. The heavy sedimentary wash on the right demonstrates the granulating nature of Ultramarine. I splashed Alizarin Crimson and Burnt Sienna in while the wash was still very wet. In the lower left of the painting, I used a wash of Cobalt Blue to encourage the eye back to the center of interest. The Cobalt Blue is smooth, soft and transparent compared to the Ultramarine, changing only the tonal value and color of the painting, but not the texture. There is no way Cobalt Blue could produce the sedimentary texture or depth of tonal value required on the right, nor could Ultramarine give the smoothness and transparency required in the foreground.

"TWO PENS" • 10" × 14" (25cm × 36cm) • Watercolor and Ink on 140-lb. (300gsm) Arches paper

The Color Wheel

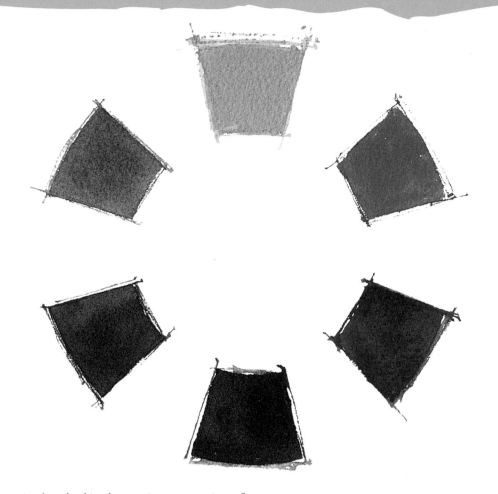

A color wheel is a harmonious progression of equal steps from one color to another. This is a very simple color wheel, showing only six steps from start to finish.

UNDERSTANDING COLOR THEORY

A basic knowledge of color theory is a real advantage for understanding colors.

❧ All colors are derived from the three primary colors—red, yellow and blue.

❧ Mixing any two of the primaries produces one of the secondary colors—orange, green or violet.

❧ Mixing a primary color on this simple color wheel with its adjacent secondary color produces a tertiary color (e.g. yellow plus orange produces yellow-orange—its complement would be blue-violet).

❧ Colors adjacent to one another on a color wheel are called harmonious colors.

❧ Any pair of colors directly opposite one another on a color wheel are complementary colors (e.g. yellow and violet).

❧ Achieve maximum color contrast by placing complementary colors side by side in a painting.

❧ Mixing any of the three primaries produces a compound color—browns, grays, earth colors, etc.

❧ Mixing complementaries produces compound colors.

❧ The pure colors—primaries, secondaries and tertiaries—contain no white or black and are called saturated colors.

❧ Any color—primary, secondary, tertiary or compound—can be made into a tint by adding white, or in the case of watercolor, diluting it with water. Adding black to any color will produce a darker shade of that color.

Colorful Combinations

When you lay out colors on your palette, keep the most commonly used ones together and within easy reach. Once you find a good arrangement, use it all the time. After a while, you will instinctively know where all your main colors are without wasting time searching. I do ninety percent of my work with only six colors, which I like to arrange on one side of my palette. Squeeze out a bit more than you think you will use in any one sitting, but don't empty the entire contents of a tube into each well. Fresh paint is much nicer to use and is always clean when you need it to be.

Most colors found in nature are compound colors—or mixtures of the three primaries. Look around and try to find a naturally occurring color not influenced to some extent by its complement—the opposite color on the color wheel. Sure, trees are green, but look carefully at the green. Is it a pure, saturated green, or does it lean toward a khaki sort of color? Most greens in nature contain some red, just as most reds contain some green. If you look at a bright red flower, even if the flower is a pure saturated red, some areas will be grayed off in shadow while other parts will come under the influence of reflected color.

The task of mixing natural-looking colors usually requires a combination of the three primaries. Therefore, you only have to buy a minimal amount of paint to mix any color you desire.

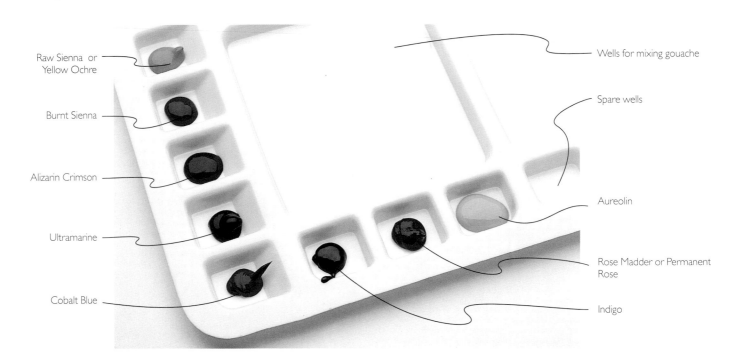

Raw Sienna or Yellow Ochre
Burnt Sienna
Alizarin Crimson
Ultramarine
Cobalt Blue

Wells for mixing gouache
Spare wells
Aureolin
Rose Madder or Permanent Rose
Indigo

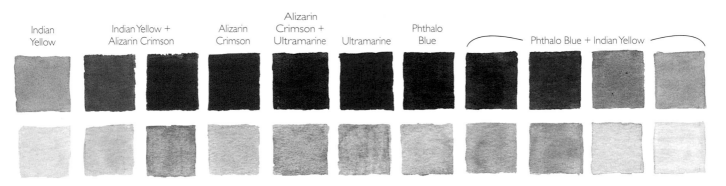

Indian Yellow | Indian Yellow + Alizarin Crimson | Alizarin Crimson | Alizarin Crimson + Ultramarine | Ultramarine | Phthalo Blue | Phthalo Blue + Indian Yellow

These four pure colors—Indian Yellow, Alizarin Crimson, Ultramarine and Phthalo Blue—mixed in varying amounts are all that you need to create a full spectrum of reasonably saturated colors. The second row of colors are diluted versions, or tints, of the top row.

Notice that the addition of Indian Yellow to Alizarin Crimson produces a warm, more Cadmium-looking red. The tint of Indian Yellow shifts the resulting color to a cooler yellow. However, if a pure, pale yellow like this is needed, use Winsor Yellow, Aureolin or Lemon Yellow. Indian Yellow is not the most permanent yellow when applied as a thin wash.

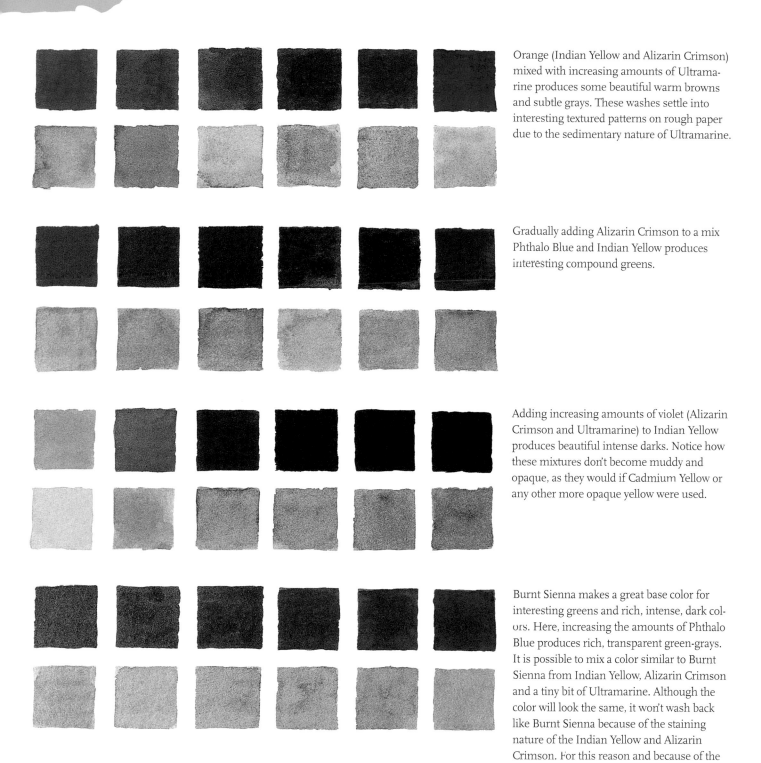

Orange (Indian Yellow and Alizarin Crimson) mixed with increasing amounts of Ultramarine produces some beautiful warm browns and subtle grays. These washes settle into interesting textured patterns on rough paper due to the sedimentary nature of Ultramarine.

Gradually adding Alizarin Crimson to a mix Phthalo Blue and Indian Yellow produces interesting compound greens.

Adding increasing amounts of violet (Alizarin Crimson and Ultramarine) to Indian Yellow produces beautiful intense darks. Notice how these mixtures don't become muddy and opaque, as they would if Cadmium Yellow or any other more opaque yellow were used.

Burnt Sienna makes a great base color for interesting greens and rich, intense, dark colors. Here, increasing the amounts of Phthalo Blue produces rich, transparent green-grays. It is possible to mix a color similar to Burnt Sienna from Indian Yellow, Alizarin Crimson and a tiny bit of Ultramarine. Although the color will look the same, it won't wash back like Burnt Sienna because of the staining nature of the Indian Yellow and Alizarin Crimson. For this reason and because of the convenience of a ready-mixed, rich, transparent red-brown, I include pure Burnt Sienna as the fifth color in my mixing palette.

Note The top row in each of these color-mixing examples shows the color at full strength with a tint (or diluted mixture) of the same color below.

Water Works

The secret to water is to have plenty of it! I use a large plastic bowl that holds a couple gallons of water. For large, full-sheet paintings, I use a plastic mop bucket.

Some artists like to work with crystal-clear water all the time. There is nothing wrong with this, but unless you are painting pale, saturated, single-color washes, it really doesn't matter if your water is a bit dirty. Since most of my paintings are done with compound colors—mixtures of three primary colors—the minute amount of pigment transferred from dirty water has no noticeable effect. When I do need to apply a clean, clear wash—a Rose Madder glaze, for example —I rinse the brush clean with my spray bottle, squirt clean water from the spray bottle into a clean well and mix up the wash.

Spray bottles are useful tools. Try to get one with a really fine mist spray and make a habit of refilling it every time you change your painting water. There is nothing more frustrating than grabbing your bottle to quickly soften an ink line or feather out a wash and getting nothing but air! A spray bottle also makes stretching paper a much easier task. In addition to soaking the paper, it allows more control when wetting the adhesive tape to fix the sheet to your backing board.

A large water container and a trigger-operated spray bottle will help you keep all your water needs under control. If you are a tidy, organized painter, this may not be important. But, if you are like me—chaos seems to build up around you as you work—find a shallow and wide container. It's much more difficult to knock over!

Begin *with the* Basics: Palettes

All of the palettes on the market look tempting when they are white and glistening in your local craft or art supply shop. So how do you choose the best one for your needs? Here are a few things to keep in mind when shopping for a new palette.

Make sure your widest brush will fit comfortably into the paint wells and choose a palette with plenty of room for mixing. If you transport your supplies to classes or paint outdoors often, buy a palette with a tight-fitting lid. Porcelain, followed by white enamel and plastic are the nicest surfaces to mix paint on. Unfortunately, the number of porcelain and enamel palettes available is low and plastic is far cheaper.

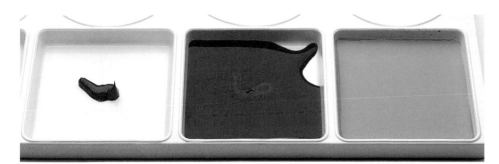

Small ceramic or plastic dishes like these are great for mixing washes. They are cheap and easy to clean, too.

If possible, choose a palette with sloping bottoms on the paint wells. This allows the paint to be squeezed onto the high side of the slope and kept clean and free of the gunk that drains to the bottom of the well. This gunk, by the way, is useful when you wish to mix browns, grays and earth colors.

Wetland Reflections

This painting will show you how simple it is to produce beautiful, glowing, transparent washes. The method you'll learn is a great way to paint skies and water. You can then splash landscape features and reflections over the dry washes using stains and sedimentary colors. It's fun, simple and produces great results!

The secret to success with these large transparent washes is to mix up more paint than you think you will need; for some reason it always disappears faster than you expect! Don't worry though, the unused portion of the wash can be applied even months later by simply stirring in some clean water.

[MATERIALS LIST]

Paints
- Alizarin Crimson
- Burnt Sienna
- Cobalt Blue
- Quinacridone Gold or Indian Yellow
- Rose Madder
- Ultramarine

Brushes
- 1-inch (25mm) flat Taklon
- ¼-inch (6mm) flat Taklon
- No. 2 Taklon rigger
- 2-inch (51mm) flat Taklon
- 3-inch (76mm) hake

Paper
- 140-lb. (300gsm) Arches rough

1 | Begin with a Wash of Rose Madder

Squeeze a dab—about half the size of a pea—of Rose Madder into a clean well on your palette. Mix in a spoonful of clean water and make sure all the paint is dissolved—check your brush, too, because pigment will sometimes hide in the bristles and put nasty stripes into your wash. Wet your paper with a large brush and clean water. Swipe a wash of Rose Madder in one bold stroke from one side of the paper to the other, about a third of the way up with your 1-inch (25mm) flat. Repeat this process along the top edge of the first wash, then, still using long broad strokes, grade the wash out into the white paper.

Tip Transparent washes tend to lighten in tone and even out as they dry, so don't worry if the wash isn't perfect after you first lay it down. Slight accidental blemishes can add character to the painting.

2 | Cobalt Blue Makes the Grade

Allow your Rose Madder wash to dry thoroughly. Wet your entire sheet with a light, even spray of clean water using your spray bottle. Spread it out with your 1-inch (25mm) flat. Mix a large puddle of Cobalt Blue in a clean well on your palette. Using your 1-inch (25mm) flat, wash a band of Cobalt Blue evenly across the top quarter of your paper. Quickly wash out and dry your brush slightly. Work with long, horizontal strokes from the middle of the paper back up across the wash, evening it out as you go. You may find it easier to turn your painting upside down to do this. If you are having trouble getting an even gradation, a dry 2-inch (51mm) or 3-inch (76mm) hake brush does a great job of smoothing out these large washes. Repeat this process, grading a Cobalt Blue wash up through the water. The Cobalt Blue washes should fade out as they cross into the Rose Madder, drying to beautiful, soft gradations from cool to warm.

3 | Create an Impression

Create the impression of land by dragging a mixture of Phthalo Blue, Burnt Sienna and a little Indian Yellow across the lower part of your painting. Next, quickly clean your brush, dry it slightly and run it along the top and bottom edges of this green line. Allow the edges to bleed and feather. Don't try to control the bleeding—this is where the damp paper and paint do the work for you.

4 | Begin to Build on

Again using Phthalo Blue, Burnt Sienna and a little Indian Yellow, mix up a slightly more brown color and create a few simple building shapes with your 1-inch (25mm) flat. You can lightly sketch these in with a pencil first if you wish. The shapes can be adjusted and tidied up later, so don't worry if they look a bit rough and dilapidated.

Soften some of the edges on this wash with a damp brush, and before the wash dries, stir a little more pigment into the mixture on your palette. Drop it loosely in around the buildings to make them stand out.

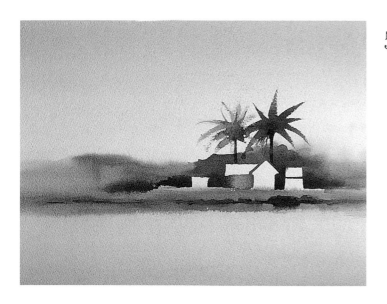

5 | Flick on the Foliage

Palm trees are great fun to paint and work well as the center of interest. The trick is to use the corner of your 1-inch (25mm) flat. Flick it out from the center of the foliage, lifting it off as you make the stroke. Vary the size and shape of the fronds slightly. Before the paint dries, drop some darker pigment into the center of the tree. It is a good idea to practice a few of these little trees on the back of an old painting or in your sketch book. Once you gain confidence, you will be surprised how easy palms are to paint. Put in the dark line separating the land from the water with the edge of your 1-inch (25mm) flat. Soften the edges with a damp brush, keeping the line interesting and irregular.

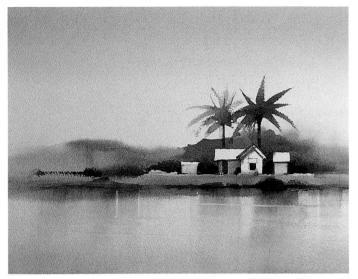

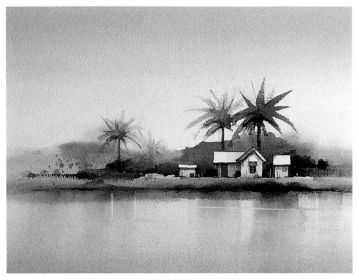

6 | **Reflect the Atmosphere**

The suggestion of soft, vertical reflections broken by a couple of horizontal ripples instantly gives this painting a feeling of mysterious calmness. It is surprising how a few simple strokes can add so much to the atmosphere of a painting! Mix a strong, dark green-gray from Phthalo Blue, Alizarin Crimson and Indian Yellow. Paint the reflections along the line separating the water and the land with a few patches of this dark mixture. Drag these patches straight down with a clean, damp 1-inch (25mm) flat. Work quickly, keeping your brush clean and not too wet by blotting it on an old towel. Keep the edges of these vertical reflections soft and blurred. All your brushstrokes should be vertical, and the whole process should take only a couple of minutes. While the paint is still wet, rinse out your 1-inch (25mm) flat, dry it and make a few horizontal marks through the damp reflections. Use the broad side of your brush toward the foreground and the thin edge of the brush near the land. While these reflections are drying, start putting some detail into the buildings. A few dark strokes with your 1/4-inch (6mm) flat and some fine rigger lines will transform these simple shapes.

7 | **Balance the Details**

You just need a few small details to finish this painting. A couple softer palms will balance things a little better. Make sure your work is thoroughly dry before wetting the area under the new palms. Use your 1/4-inch brush to apply the fronds, letting them bleed out as they dry. Flick in a few contrasting sharper fronds as the paper dries. Spark some interest with your trees by making one or two of the fronds in the main tree softer and paler. Add some life to the buildings by putting a patch of pure Alizarin Crimson on the awning and at a few spots around the buildings. Contrast this with some Ultramarine shadows under the eaves. Scrape in some harp highlights with a razor blade after the painting is completely dry.

Tip Spreading an old towel over your work table makes it easy to quickly adjust the moisture content of you brush.

Street Cafe

This little cafe on a busy street makes a great subject, full of color and movement. It is ideally suited to the strength and richness of staining pigments. Get as much color and excitement into this painting as possible. As you work with these staining colors you will notice that they invade one another. Underlying colors bleed up through overlayed washes to influence the final color's appearance.

[MATERIALS LIST]

Paints
- Alizarin Crimson
- Quinacridone Gold or Indian Yellow
- Burnt Sienna
- Winsor Red
- Phthalo Blue

Brushes
- 1-inch (25mm) flat Taklon
- ¼-inch (6mm) flat Taklon
- No. 2 Taklon Rigger
- 3-inch (76mm) hake

Paper
- 140-lb. (300gsm) Arches rough

Other Supplies
- Brown pastel pencil

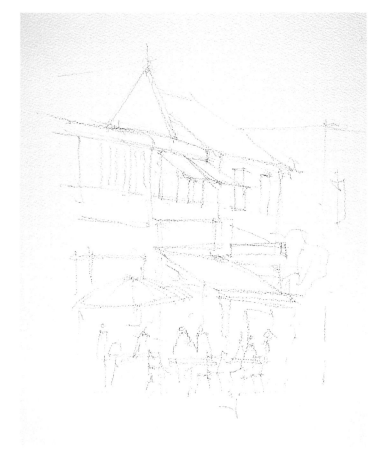

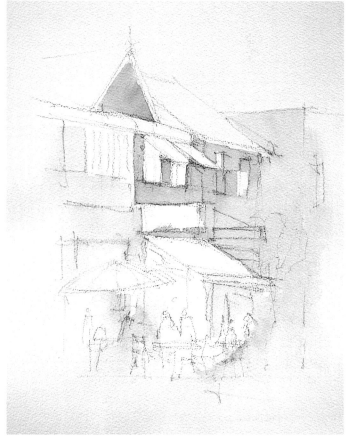

1 | **Begin with a Sketch**
First, loosely draw in the building shapes. If you use a pastel pencil and sketch it in fairly lightly, some of the lines can remain as parts of your finished work. Unwanted lines can be dissolved into your washes. These rough lines add looseness and excitement to your finished painting.

2 | **It's Okay to Be Messy**
Loosely and quickly splash a weak mixture of Indian Yellow and Alizarin Crimson over most of the building surfaces to define the buildings. Avoid painting the roofs, windows and awnings at this stage. Aim for some variation in the strength of these washes. Slop it on roughly and unevenly! The trick here is not to produce a smooth flat wash, but to make an interesting foundation to build up on.

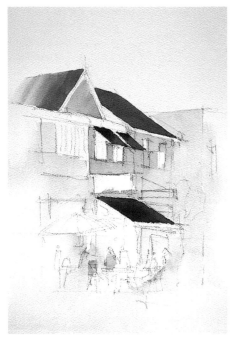

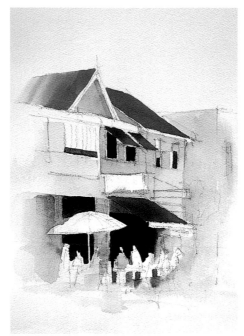

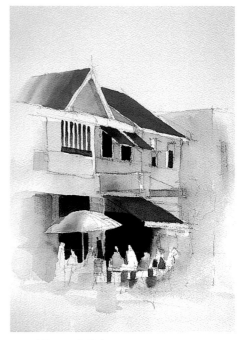

3 | **Go Crazy with Color**

Put some strong, pure Alizarin Crimson on the awnings with your 1-inch (25mm) flat. While it is still wet, wash out your brush, dip it into some Winsor Red and drop that into the Alizarin Crimson. As it dries you will see a vibrant change across the awnings from warm (Winsor Red) to cool (Alizarin Crimson) red, giving the awnings much more life and interest than a pure version of either of these colors.

Paint the roofs with a terra-cotta color mixed from Winsor Red and Indian Yellow. Grade the roof on the side from dark to light as it approaches the side of the painting. While this dries, put a couple blobs of Indian Yellow in the foreground. They may not look like it now, but they will eventually become figures in your painting.

4 | **Focus on the Figures**

Focusing attention on the foreground figures requires strong tonal value contrast. Mix up a rich, cool, dark gray using Alizarin Crimson, Phthalo Blue and Winsor Yellow. Carefully cut in around the figures in the foreground. A small dot for a head and a tapered blob for a body are all that are required. It is amazing how little information is required to give the impression of people. While you have this cool gray mixed, add some dark windows and door shapes. Again, as you work toward the left side of your painting, dilute the mixture considerably, losing detail and intensity toward the bottom left corner. Use this diluted gray to push the building on the far right back into the distance. A light wash over this distant building will cause your main buildings to leap forward and dominate the painting.

5 | **Play with Color**

Now it's time to squeeze some more life out of these colors. A cool contrast to the reds, ochres and terra-cottas will provide the vibrancy you are after. Mix Winsor Yellow and Phthalo Blue.

Using the edge of your 1-inch (25mm) flat, carefully put in a striped green blind. Work from left to right if you are right-handed and vice-versa. Before the stripes dry, drop a little pure Phthalo Blue into the top of each stripe so they appear darker toward the top. Wet the umbrella with clean water. Bring your green mixture to life with a drop of Phthalo Blue and flood it in, working up from the bottom left edge. Add contrast to the signs on the buildings and some of the other figures with cool blues and greens now.

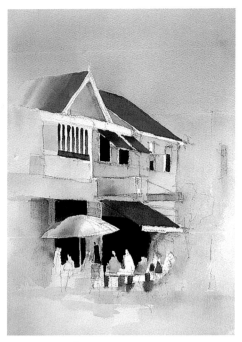

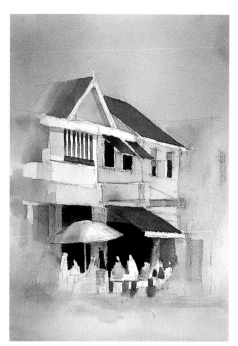

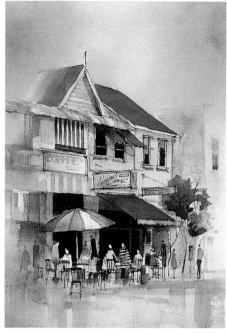

6 | Reach for the Sky

Now you get the chance to make the warm colors really leap off the paper! Thoroughly wet the sky and mix a pale wash of pure Phthalo Blue. Cut it in carefully around the roofs, but allow it to spread down into the lost section of the building on the left. Push the wash down across the distant building on the right and into the foreground. Make this wash soft and blurred except where it meets the terra-cotta roofs.

7 | Lead with Light

Create a path of light through the sky that will lead the eye toward the center of interest by simply darkening the sky at the outer edges of your painting. After your first wash has dried, wet the sky and lay a vertical wash down on either side. Allow the washes to feather out toward the center, leaving a nice, smooth gradation from dark to light.

Mix a small amount of Alizarin Crimson into the Phthalo Blue on your palette to make a slightly pale purple-gray. Work this loosely over the left of each building, adding a couple patches of orange—a mixture of Winsor Yellow and Alizarin Crimson—to suggest detail. The same purple-gray can be used to model the umbrella and add some darker patches to the right of the figures.

8 | Work Small for Big Fun

Now is your chance to have fun with your smaller brushes. Add all those little details—window frames, signs, timber joints, chairs and tables—anything that adds interest to the surface. Use your ¼-inch (6mm) flat to suggest bricks in the distant building and subtle writing on some of the signs. Paint the tree on the right with your 1-inch (25mm) flat and a mixture of Indian Yellow and Alizarin Crimson, adding a tiny amount of Phthalo Blue to the lower part of the foliage. The limbs and branches can be flicked in with your rigger brush. Add some grayer, less significant figures to both sides of the main group. These make the scene more active and add interest to these less important areas. Repeating the stripes of the blind in the building facade and the foreground figure helps unite the painting.

DISCOVER
different ways to paint

Have you ever looked at a painting and thought, "Wow that's fantastic! How did they do that?"
⊚ In this chapter you will experiment with many different techniques and ways to you use them to enrich your paintings. You'll discover ways to use multiple brushes and gain more control over your work. You will experiment with ink, pastel pencils, gouache, masking fluid, gesso and collage, and have fun with household items that can add variety and interest to your paintings. Use cling wrap, candle wax, sandpaper and even a sharp stick to stretch your work in new directions. One of the most exciting aspects of painting with watercolor is discovering new techniques that can be used to add depth and mystery to paintings. You can do the exercises in this chapter on small, postcard-size sheets of watercolor paper and keep them in a folder for future reference.

Random splashes and cling-wrap wash textures give a bleak, stony barrenness to this isolated Italian hillside.

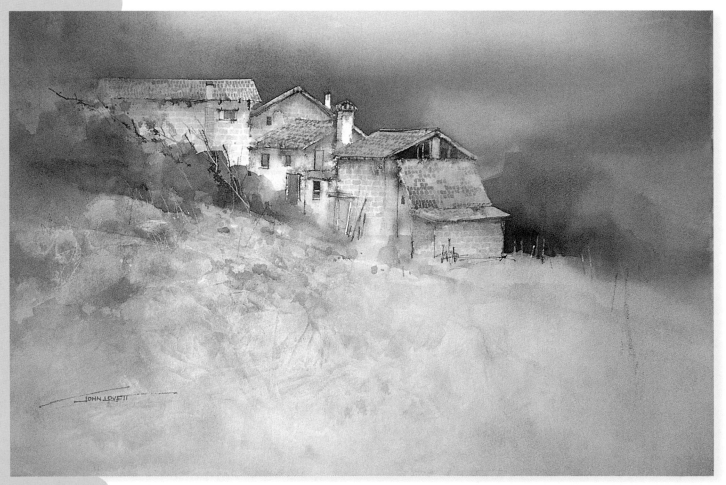

JOHN LOVETT

ON A WINDY HILL • 15"× 22" (38cm × 56 cm)

Begin *with the* Basics: Brushes

Artists' brushes come in all shapes and sizes, and although they all simply make marks on paper, certain types of brushes are designed to produce specific types of marks. You don't need to buy a huge range of brushes when getting started, but a few different types and sizes will make painting easier and much more fun.

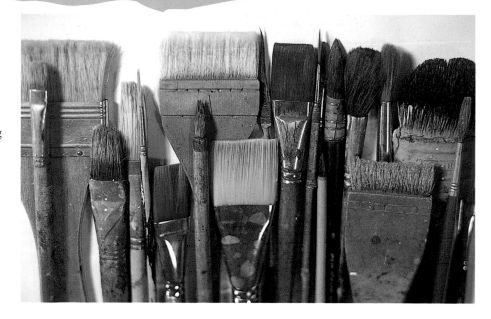

Square

Square brushes are great for painting geometric shapes such as buildings, machinery or most man-made objects. Their square corners produce clean, sharp angles and make right angles solid and convincing. I use two square brushes, a 1-inch (25mm) and a 1/4-inch (6mm). Both have long, synthetic Taklon fibers. They hold plenty of water, wear well and are reasonably priced.

Round

Round brushes are more suited to organic subject matter, for which the strokes produced by the geometric corners of a square brush would look out of place. Pure Kolinsky sable is the best bristle for a round brush. It forms a beautiful point, holds plenty of water and always springs back into shape. Large sable brushes are very expensive. A cheaper option is a squirrel hair mop brush. These don't spring back into shape like a sable, but they do produce very expressive, organic lines and are great for squeezing color onto wet paper.

Liner or Rigger

No. 2 liner brushes are ideal for fine details and long, thin lines. They have long, thin bristles and hold a surprising amount of paint. Held perpendicular to the paper, these brushes will make the finest lines, adding a sharp crisp finish to your paintings. Liner brushes are available in sable, but I find the Taklon fiber variety works just as well.

Hake

Hake brushes are traditional, handmade, Chinese goat hair brush, and are ideal for watercolor washes. You can use them to apply a wash, but their greatest benefit is that they can even out patchy washes. Used dry over a wet patchy wash, hake brushes evenly redistribute pigment and moisture over the surface. Hake brushes range from approximately 1-inch (25mm) to 4-inches (101mm) in width. I find that sizes between 2-inches (51mm) to 2 1/2-inches (64mm) work nicely.

Get Wild *with* Your Brushes

1-inch (25mm) Flat

The controlled release technique takes advantage of your paper's texture. It works well for showing light reflecting off water or for the grainy surface of weathered timber.

Splashing paint—in the right amount and the right spot—can add a loose excitement to your work. This sounds simple, but does require quite a bit of practice to keep the splashes carefully aimed and under control.

Feathering is the technique of softening hard edges. When you apply watercolor to dry paper, a hard, sharp line usually surrounds the resulting shape. This can give your painting a fussy, overworked appearance. Avoid these hard edges by feathering or softening them.

Practice this technique on watercolor paper because cheaper papers will absorb the pigment too quickly for feathering to take place.

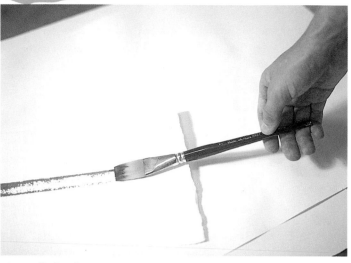

Controlled Release
Load your brush with paint and drag it slowly across your paper, lowering the handle as you go. When the handle is almost parallel with the paper, your brush will no longer release paint. The effect you're after occurs just before the brush stops releasing the paint. You should be able to lift and lower the handle slightly to control just how much paint is released.

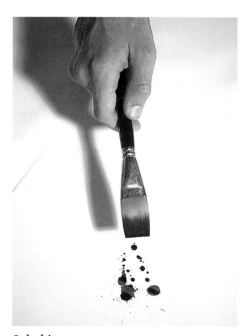

Splashing
Load your brush with plenty of paint. With a firm, downward movement from the shoulder and elbow, not the wrist, bring the brush to an abrupt stop. This firm motion prevents any kickback from the brush. Flicking with the wrist only encourages the brush to splatter back, causing paint to go everywhere! Ten minutes of practice on an old sheet of newspaper will have you splashing paint with confidence.

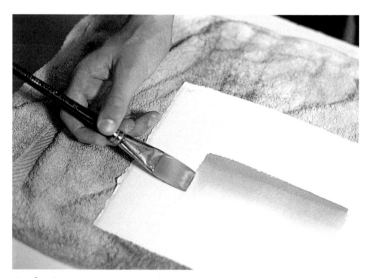

Feathering
Apply a line of watercolor, then immediately rinse the brush clean and dry it slightly on your towel. Gently run it along the hard edge of the mark you just made. Make sure the brush has enough moisture to create a damp area for the pigment to feather into. Too much moisture will make the pigment form another hard edge farther out. Too little moisture will allow the brush to lift off pigment.

To achieve a nice soft, feathered edge, you may have to run the brush over the edge a few times. Rinse and adjust the moisture in the brush each time.

Hake

Large washes sometimes can appear patchy and uneven. A hake brush used gently while the wash is still very wet tidies up these uneven washes.

Mop

This type of wash gives beautiful, flowing, feathered marks great for skies and water.

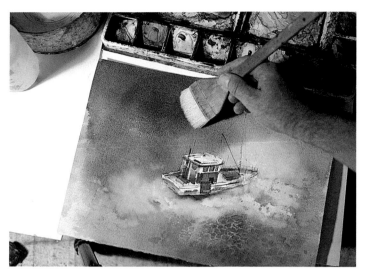

Smoothing out a Wash with Your Hake

The secret is to very lightly whisk the brush over the wash in different directions, drying it every few strokes on an old towel. The brush will absorb excess water and evenly redistribute pigment. A good way to practice this technique is to do some graded washes over an old painting you are not particularly happy with.

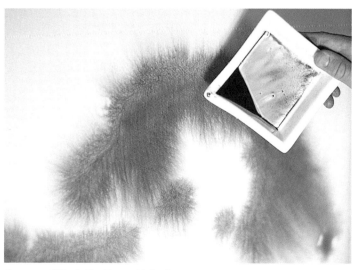

Squeeze Wash for Large Paintings

You can take the mop wash process a step further for really large paintings on oversized paper. Simply transfer the paint to the paper by pouring it directly from a mixing dish.

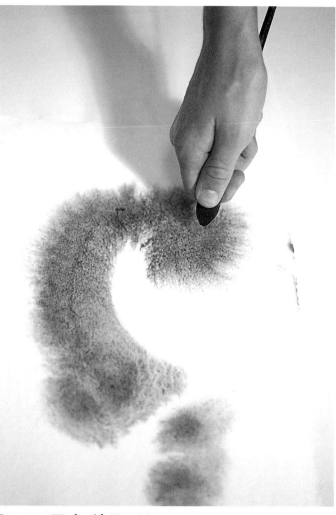

Squeeze a Wash with Your Mop

Mix a large pool of color, then wet your paper thoroughly with clean water. Soak up as much of your mixed pool of color as possible with your largest mop brush. Don't brush the paint onto the paper. Instead, squeeze it out with a sweeping motion above the paper, letting it drop to the surface. Once the paint lands on the paper, don't touch it. You can make adjustments by applying more washes after the paper dries.

Rigger

A rigger brush makes drawing long, straight lines easy. Here are a few, simple steps to make the process foolproof.

Make sure you draw the line toward you; you may have to turn your painting around to do this. Load your brush with a fairly wet mixture to ensure it flows evenly off the brush. Don't press your brush down onto the paper. If the weight of the brush is not enough to make a mark, mix some more water into the pigment. Before you paint the line, decide where the start and finish points will be, and turn your painting so these points line up toward you.

Make sweep lines—fine, freehand lines drawn with a rigger brush—with movement from the shoulder and elbow, not the wrist. Keep the brush perpendicular to your paper. Unlike dragged lines, sweep lines are drawn across the direction of your body—left to right if you are right-handed and right to left if you are left-handed. Make your movement definite and controlled.

It is possible to rule lines with your rigger brush. You will need a ruler guide made from an old paint brush handle and a pin.

Dragged Lines

Hold your brush loosely by the very end of the handle, rest the bristles on the starting point and drag the brush under its own weight in an even, straight line toward you. Practice this technique on old sheets of newspaper. Make sure the paper is flat or your line will have bumps in it.

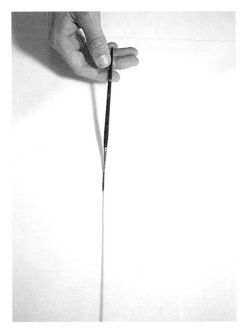

Sweep Lines

Load your brush, then, holding it perpendicular to the paper, place the tip on the starting point. Move your brush smoothly, quickly and confidently to the finish point, stop, then lift it off. Throughout the whole process, the brush should remain perpendicular to the paper. Don't start to lift the brush off before you reach the finish point or you will lose control of your line. You may find it helpful to rest your little finger on the paper as you make the stroke.

Ruler Guide

Make a simple ruler guide by cutting the handle of an old brush with the same diameter as a pencil and hammering a pin into the cut end. Now you have a gadget with two points that will touch the surface—the pin will follow the ruler's edge while the brush makes a clean line that won't be blurred by contact with the ruler.

Ruling Lines

Hold the ruler guide behind your rigger brush so the brush tip barely makes contact with the paper. Then simply run the guide and brush along the edge of a ruler.

This technique produces accurate, reliable lines, but they tend to lack character compared to freehand sweep lines.

Pencil *it* In

If you like to paint in a loose, sketchy manner, pastel pencils are a great medium for your initial drawing. They are made from light-fast pigments that don't fade or change hue over time. They are similar to hard or soft pastels, and their marks can be left as part of your finished work. They are better than hard or soft pastels in that they can be sharpened to a reasonable point and their chalky consistency makes them easy to rub back or dissolve with water. Pastel pencils are softer and more subtle than watercolor pencils, but the two are often confused. They are also usually located next to one another in the art supply store, so ask your art supplier if you can't find them.

Pastel pencils are available in a full range of colors, but a few grays and earth colors are enough to get started.

Tip Handle your pastel pencils very carefully. Once a pencil has been dropped, the core shatters and it becomes useless. Sharpen pastel pencils with a craft knife.

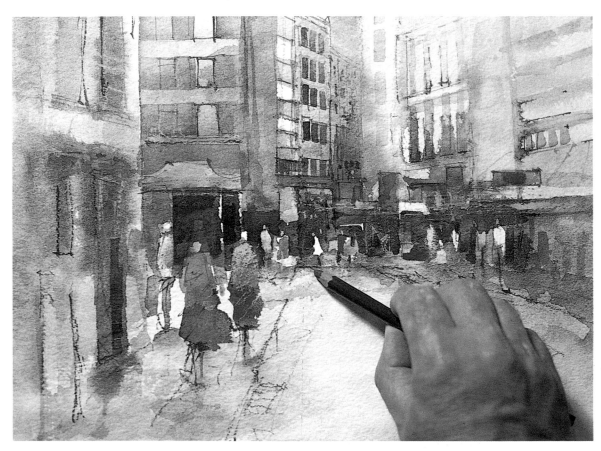

Pastel pencils are great for initial drawings, as well as loose, linear details in your painting. You can paint over pastel pencil lines with watercolor, rub them back with a clean finger or leave them intact.

Washed Ink

Use this technique to produce the realistic textures of brick and stone walls, rocks, grass, sticks, etc. Apply washed ink before your watercolor washes, because once it is dry, you cannot wash it off.

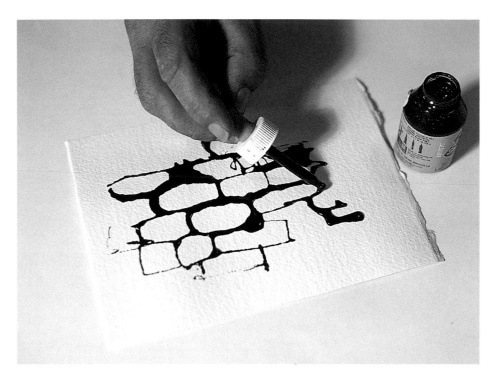

Apply your ink with a brush or the dropper that comes with the bottle. Try to vary the amount of ink deposited from fine lines to thick blobs. Thin patches dry faster and leave darker, more definitive shapes. Thick areas remain wet and wash away leaving fine, out-lined shapes. Let the ink dry for about five minutes, then use your spray bottle to wash away the ink. If the ink is left too long you may have to use an old bristle brush to scrub it back.

Washing back the residue from the ink leaves an interesting cast over the paper and a variety of unpredictable lines and shapes.

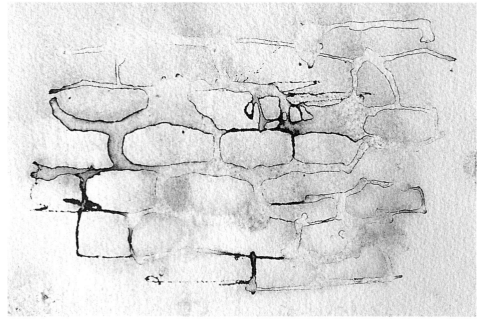

Sprayed Ink

Apply fine lines of waterproof ink over your painting and lightly spray them with water so they spread and soften. Use a dip-in pen with a plain nib to apply the lines. Work fairly quickly, as the ink dries quickly and becomes insoluble in water. Draw in a couple of lines, adjust your spray bottle to produce a fine spray and lightly spray them. The ink will spread quickly into fine, spidery marks. This technique is great for casting an aged, weathered patina into your painting.

Apply your ink lines to one small area at a time. This way you can spray them with water before the ink dries. Also, it is best to have a tissue handy in case your pen drops blobs of ink.

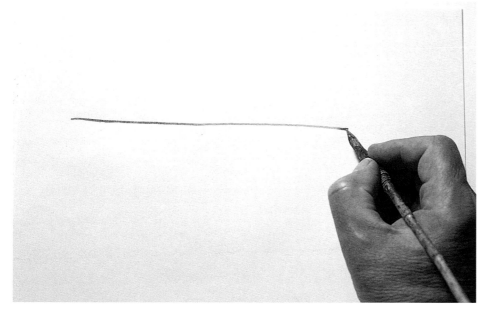

Spray on just enough water to make the lines run. After spraying a few lines, the paper may be wet enough to make subsequent lines run without more spraying. Try to make the paper unevenly damp so the lines pass through tiny patches of both wet and dry paper.

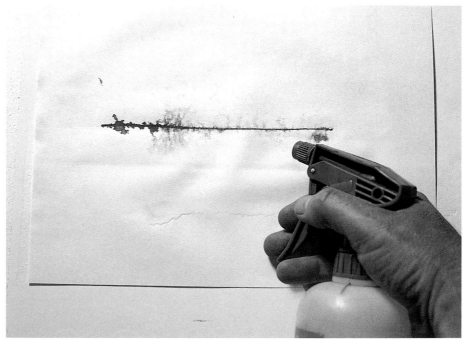

Cling-Wrap Wash

This simple household item will take your washes to a new level and give you spectacular and unpredictable results. This technique is ideally suited to create the look of ancient rocks and add life to your foregrounds where an interesting but subtle texture is needed.

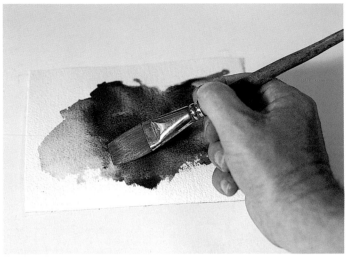

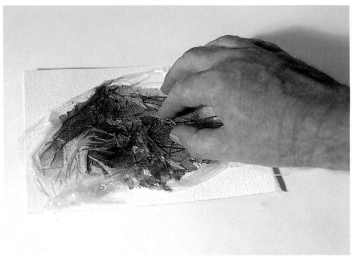

Mix up a runny wash of Burnt Sienna and spread it randomly on your paper. While it is still very wet, add some more concentrated Burnt Sienna and a little Ultramarine. Don't mix the colors; let them bleed into each other.

While your wash is still runny, spread a piece of cling wrap over the paper. Make sure it is creased and wrinkled. Notice how the paint concentrates along the edges of the plastic where it comes into contact with the paper. You will also see extraordinary textures begin to form as the covered wash dries. You can move around the cling wrap to influence the roughness and direction of the texture.

The paint will take a while to dry, but don't be tempted to remove the cling wrap until the paint is thoroughly dry, or the effect will be ruined. The results are worthwhile and there is no other way to produce this type of texture.

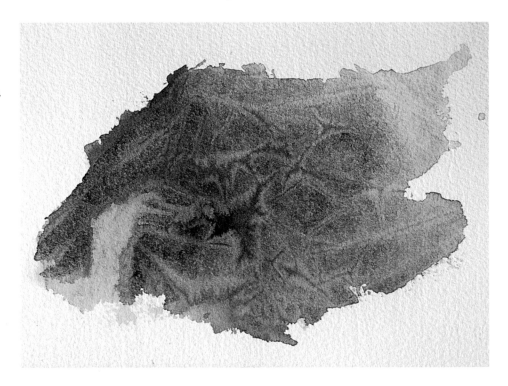

Candle Wax Lines

This layering process is ideal for areas of a painting that contain overlapping, repetitive elements such as grass areas, trees and leaves. Apply a wash, allow time to dry completely, and then draw over the wash with candle wax. Repeat this process to build up and create an interesting three-dimensional surface.

Apply wax to the areas of white paper you want to preserve before applying any washes.

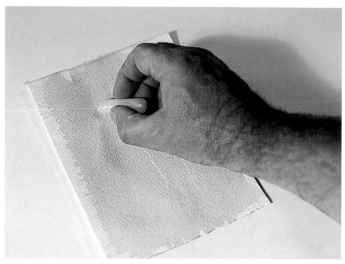

Apply a light-toned wash to the paper and allow it to dry before drawing more wax lines.

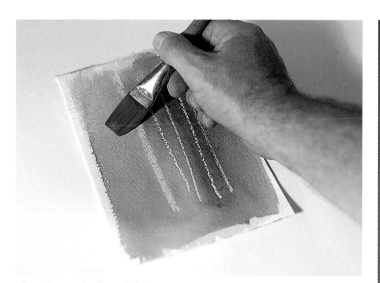

The color gradually will darken as the process is repeated.

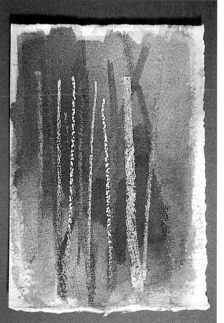

Scrub back the washes after the wax has been applied to the darkest wash for an interesting variation on this technique as in the top and bottom corners.

Masking Fluid

Similar to candle wax, masking fluid will resist watercolor. The fluid is a removable rubber latex solution that preserves clean or painted paper. Your original surfaces will be revealed when you rub the masking fluid from your finished painting. Apply masking fluid to a dry surface using an old brush, sharp stick or a dip-in pen. A dip-in pen will give you nice fine lines that are difficult to achieve with a brush. In the following exercise you'll use layers of masking fluid to build up the light tones of an old fence against some dark bushes.

Apply a wash of Raw Sienna or Yellow Ochre, and while it is wet, drop in some Burnt Sienna and Ultramarine. You want to produce a pale wash that varies slightly in color. Don't be too fussy; the only parts of this wash that will be visible in the final painting are the areas covered by a few of the lightest-toned fence posts.

Let your paper dry thoroughly, then, using an old bristle brush—I use a 1/4-inch (6mm) flat—and a dip-in pen, draw in a few fence posts with your masking fluid.

After your masking fluid has dried, wet the paper and apply a slightly darker patch of Burnt Sienna and Ultramarine to the area immediately behind the posts.

When the paper has dried out again, draw in some more posts with your masking fluid. Vary the size, spacing and angle of your posts to make the fence look interesting. Let this second application of masking fluid dry, then paint a darker mixture of Burnt Sienna and Ultramarine behind the posts. This time don't wet the paper and keep a fairly hard line along the bottom of the posts. Soften the top of this wash with a damp brush before the wash starts to dry.

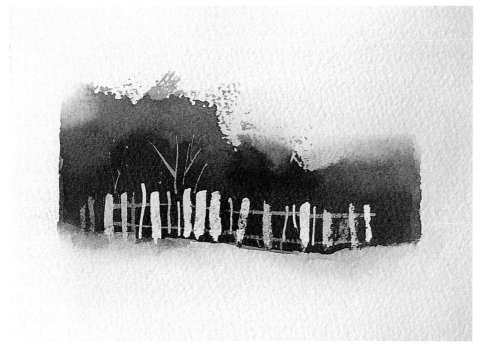

Add a final application of masking fluid to define the horizontal fence rails. Use your small, old bristle brush and make the lines as fine as possible. Just for fun, mask in some tree branches with your dip-in pen. Let the masking fluid dry, then wash in some dark bushes with varying mixtures of Indian Yellow, Burnt Sienna and Phthalo Blue. Splash some Alizarin Crimson into this wet mixture to put some life into the fence. Let these washes dry thoroughly, then carefully rub off the masking fluid with your finger.

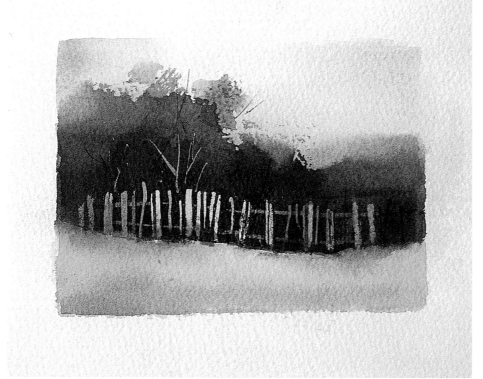

Now you should have an interesting background of bushes with a fairly raw, rough fence in front of them. Next, sharpen the posts with your rigger brush. Make the tops square and reduce the size of some of the larger posts if needed. Blend some of the hard edges produced by the masking fluid into the background with your rigger. Establish a center of interest about one-third of the way along the fence—from left to right—with a graded wash over both ends of the fence. Apply this graded wash with your 1-inch (25mm) flat and a mixture of Burnt Sienna and Ultramarine. Use the same mixture to mesh the bottom of the posts into the ground. All you need now is a graded wash of Cobalt Blue through the sky and a graded wash of a mixture of Indian Yellow and Phthalo Blue through the foreground. Add a shadow in the immediate foreground with Ultramarine and Burnt Sienna.

Gesso and Gouache

Gesso is an acrylic primer designed to coat canvases and boards for acrylic and oil painting. Depending on the type of brush you use, such as an old bristle brush, gesso can help you create texture and vary the surface of your watercolor paper. Whether it's a big abstract mark through the foreground of a landscape painting or a few random bricks picked out of the wall of a building, varying the paper's surface in this way always adds excitement and variety to your painting.

Placing areas of pure opaque gouache into an otherwise transparent watercolor paintings introduces a wonderful surface contrast. White gouache mixes well with watercolor pigments to produce flat pastel colors. The watercolor's transparent glow is made even more vibrant when contrasted with the velvety flatness of the gouache.

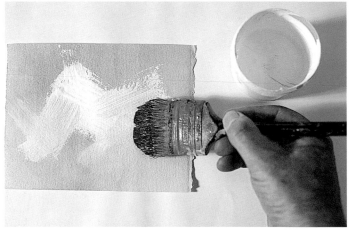

Gesso is best applied with an old bristle brush to give the surface a coarse texture. Try diluting some of the gesso with water. In this example I have thinned out the gesso in the lower right-hand corner. It will react quite differently from the rest of the gessoed area when the watercolor wash is applied over it. Let your gesso dry thoroughly before experimenting with different washes.

Try a sedimentary color like Ultramarine; notice how it concentrates in the depressions of the gesso's texture. Watch how the watercolor washes behave on the area of diluted gesso.

After your washes have dried, try lifting some of the pigment off the gesso with a damp brush. You will find that a color that was applied over gesso is much paler than the same color painted onto paper and can be lifted off with ease.

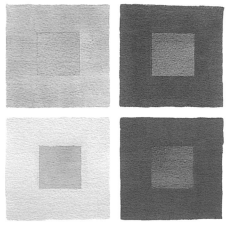

In this example washes of Alizarin Crimson, Ultramarine, Indian Yellow and Phthalo Blue are surrounded by white gouache tinted with each of the pigments. This example helps you get the feeling of the full difference between opacity and transparency.

Dropping In and Lifting Off

Dropping in paint is simply a method of introducing another color to an already wet wash. The color mixes and blends on the paper for a more eclectic surface than colors premixed on the palette. You can also use this technique to apply paint to areas of white paper.

Almost as important as painting in watercolor is the ability to lift off paint. Painters almost unconsciously lift off paint to adjust tones and colors as they paint. They also deliberately draw into dark areas with a damp brush to lift off pigment. Planning ahead will pay off in this case. If you used staining colors, lifting off paint will be much more difficult. If you intend to lift paint off a dark area after it has dried, use nonstaining colors such as Ultramarine and Burnt Sienna. It is best to lift off pigments soon after the paint has dried. After the paint has dried for a couple of days, the pigment tends to set and washing back becomes more difficult.

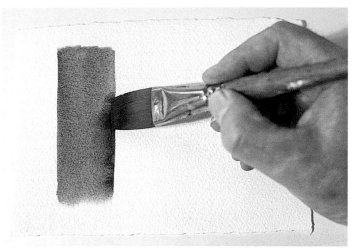

Mix a fairly pale wash of Alizarin Crimson. Apply a rectangular patch about 1 inch (3cm) wide and 3 inches (8cm) long using your 1-inch (25mm) flat. Don't make it too wet, just wet enough so the dropped-in color will bleed. Next, mix some Alizarin Crimson and Ultramarine, and make it a little darker than your first wash. Drop it in along one edge of your first wash by gently touching the edge with the broad side of your loaded brush. Your drop-in color requires only the lightest touch to be drawn into the wet wash. Put in a little at first and if necessary, drop in more while everything is nice and wet.

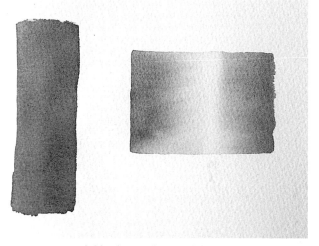

Dropping into a wet wash like this produces subtle and unpredictable blends of color, depending on the pigments used. Create a metal tank appearance by dropping Ultramarine and Burnt Sienna into the sides of a wet rectangle on clean paper.

Paint a dark wash of Ultramarine and Burnt Sienna and let it dry before lifting off patches with a damp brush. Try brushes of different sizes and experiment with varying amounts of dampness. If you want to lift pigments off a large area, first wet the area, then work the brush over it to dissolve and dislodge the pigment. After the pigment has been softened, it is easy to lift off with a damp brush. You may have to rinse and dry the brush several times while lifting one area. Tissues or paper towels can be useful here. Use a piece of paper as a mask to lift off along a sharp line.

Japanese Rice Paper

Japanese rice paper comes in a variety of colors and textures. Attach it to your watercolor paper with PVA (craft) glue slightly diluted with clean water. Be careful not to let the glue ooze out from under the rice paper or shiny marks will be visible. Wash watercolor onto the rice paper and surrounding watercolor paper to build up unique textural effects. These effects are unpredictable, but work well in areas that require heavy texture—rocks, foliage or stone walls, for example. Splash paint around the rice paper to blur the boundary between the two papers so the rice paper appears to fuse seamlessly with your paper.

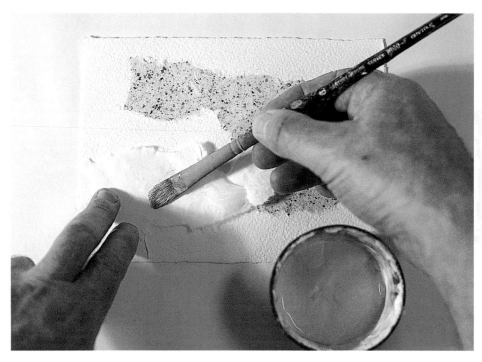

Roughly tear your rice paper into suitable shapes and attach them with diluted PVA glue. Cover it with a sheet of clean paper and rub it with the palm or your hand.

Tip PVA glue has a neutral acid content and is safe to use on your paintings. Apply it with an old bristle brush, but be sure to wash the brush out thoroughly before the glue starts to dry.

Apply washes over the rice paper before the glue has dried. If the torn edges of the rice paper absorb too much paint and appear too strong, drop some white gouache along the edge with your 1-inch (25mm) flat brush.

Pressing Into Wet Paint

Spice up your details and textures of your wet washes by pressing a sharp stick or metal nail file into the paper. These lines make an intriguing contrast to harder, sharper lines that are added with a brush once the wash has dried.

You can use all kinds of objects to create attractive details. Lay them on the wet paint, cover them with a piece of cardboard and press them into the wash. Apply plenty of pressure; the back of a spoon is a useful tool for applying pressure. Make sure the objects you choose will stand up to the pressure you will apply.

You can press lines into watercolor paper, which will absorb the surrounding pigments and maintain close color harmony in your painting.

Press a fern frond like this or other leaves into wet paint to make new and exciting marks. Don't make the wash too dark because the pressed lines need to appear darker than the initial wash.

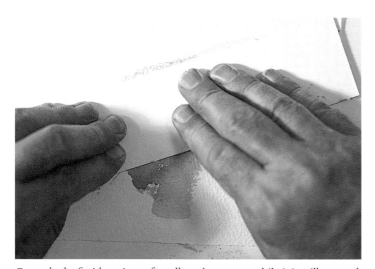

Cover the leaf with a piece of cardboard or paper while it is still wet and rub hard to press the leaf into the paper.

The result is a subtle outline of the leaf's details. You can use this technique as the basis for your next painting.

Drawing with Neat Paint

Draw on wet paint with an additional undiluted color to liven up your painting. Use the back of a brush or a sharp stick dipped straight into the paint. The resulting line will be rough, lumpy and random. The result can be a little unpredictable, depending on how wet the paper is. Don't try to control these lines too much; the roughness and unpredictable nature gives them character.

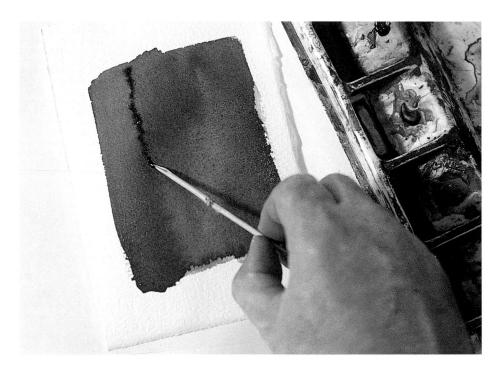

Start with a fairly wet wash, then pick up a lump of pure paint with your sharp stick. Draw into the wash, twisting the stick as you go. These rough, random lines work well in areas of heavy texture. Dark patches in a painting (open doors and windows for example) sometimes look a bit dead if the dark is neither warm nor cool. Pick up a lump of pure Ultramarine and draw it into the dampened dark patch to add life and transparency to a dull painting.

Try to keep your lines under control; wet just a small area at a time to apply them.

Scraping and Sanding

Add crisp, sharp highlights to your work after your painting is thoroughly dry by scraping through the paint surface with a razor blade or sharp knife. Or create subtle textures by lightly sanding the paint to reveal some of the white paper underneath.

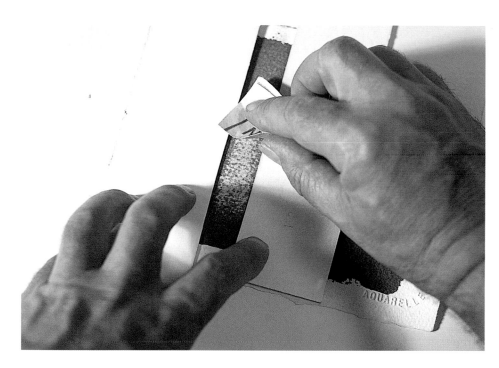

Two pieces of cardboard make handy guides when you want to finish sanded areas with straight edges.

Paint a piece of paper and let it dry thoroughly. Then practice these sanding and scraping techniques. You can save paper and see the effects of the techniques side by side.

Out to Sea

This painting of an old wooden ketch heading out to sea gives you the opportunity to try a variety of brush techniques using a number of different brushes. For this demonstration, I used a full sheet of Arches rough paper stretched on a board. It is not necessary to work this big; if you prefer, the same painting can be done on a quarter sheet.

[MATERIALS LIST]

Paints

- Alizarin Crimson
- Cobalt Blue
- Phthalo Blue
- Quinacridone Gold
- Scarlet Lake
- Ultramarine
- White gouache

Brushes

- 1-inch (25mm) Taklon flat
- No. 12 mop brush
- No. 2 Taklon rigger
- 3-inch (76mm) hake

Paper

- 140-lb. (300gsm) Arches rough

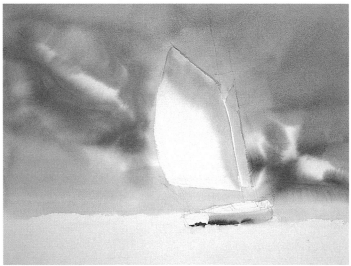

1 Begin with Wet-in-Wet Washes

Draw a light, loose sketch to get an idea of where the main washes should go. Apply the first wash of the main sail wet-in-wet. Use a hake or 1-inch (25mm) flat to completely saturate the entire sail area with clean water. While the sail is wet, mix a gray on your palette using Ultramarine and Burnt Sienna. Fully load your mop, and place a band of shadows across the top and down the inside edge of the sail. With the same color, this time use your 1-inch (25mm) flat, paint the small portion of the front sail. Mix some more Ultramarine into the gray on your palette for the cool shadow color for the hull. Apply this to the dry paper with your 1-inch (25mm) flat. Create a dark mauve by adding some Alizarin Crimson and Ultramarine to the gray you used for the cool shadow that is already on your palette. Drop this into the bottom of the wet hull and allow it to bleed out with the tip of your mop.

2 Squeeze on the Sky

This step requires a little preparation. First, mix up a large pool of Cobalt Blue and clean water. Next, soak the entire sky area with your hake and clean water. Cut in carefully around the sails and boat. Use your hake like a broom to work the water evenly over the surface of the sky. Try to avoid any pools or dry patches. Once the sky is evenly wet, soak your mop brush in water, squeeze it out, and soak up as much of the Cobalt Blue mix as possible. The trick now is not to paint the paper, but to squeeze the pigment out between your fingers as you sweep your brush just above the surface of the paper. Let the paint drop to the surface and bleed and flow wherever it likes, avoiding the sails, of course. I trailed the paint in a diagonal direction up toward the top left corner. While the wash is still very wet use the hake to even out some areas of the sky. I evened out mainly the top right and bottom left to reinforce my diagonal direction. The secret is to leave most of this random wash to its own devices. It may look a little wild and unruly when first applied, but as the wash dries out it will settle down considerably, leaving beautiful, random effects.

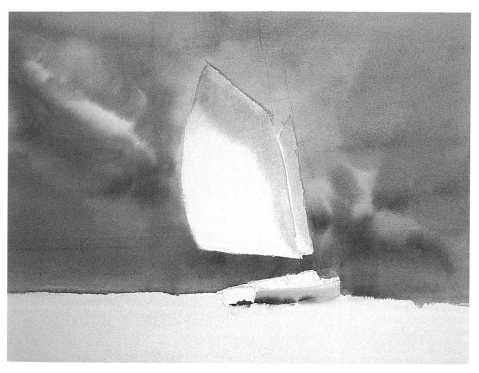

Contrast is the Key

3 | Reduce the contrast in the lower region of the sky, and increase the contrast between the sky and the main sail with a Cobalt Blue wash. Allow the painting to thoroughly dry, then wet the sky area again and grade a wash of Cobalt Blue from the horizon up with your hake. This wash only needs to cover the bottom quarter of the sky before fading out completely. Be sure to wet the entire sky area to ensure that no hard line forms between the Cobalt Blue wash and the underlying wash.

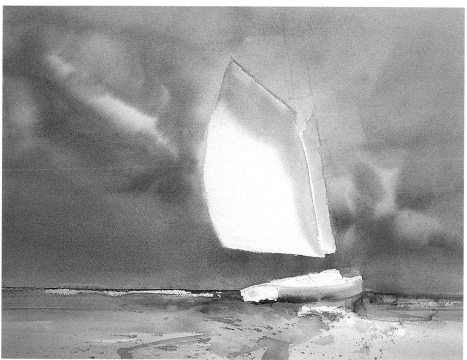

Splash in the Water

4 | Give the boat a feeling of movement by painting the water very loosely. Use your big, rough, old house-painting brush—you don't need to be tidy here—with varying mixtures of Ultramarine, Phthalo Blue and Alizarin Crimson to make the sea appear slightly purple toward the horizon. Emphasize the movement of the yacht by roughly dragging a few lines diagonally up from the bottom left toward the boat. Capture the light on the breaking water using the dragging technique described on page 48. Remember to lower your brush handle until it is almost parallel to the paper.

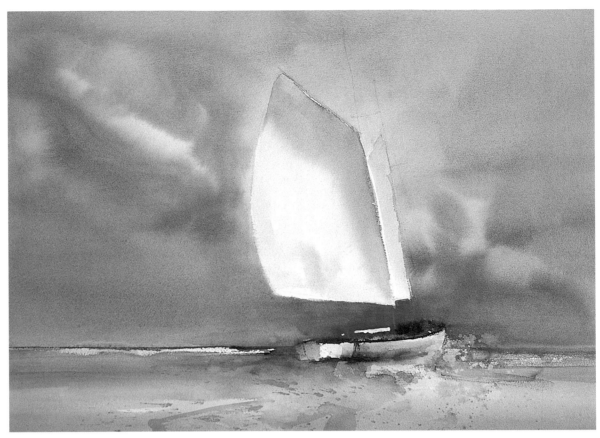

5 | Let Your Colors Sing

Before you add some strong color to liven things up, add a more intense wash of Cobalt Blue around the top of the hull to focus more attention on the boat. Allow the Cobalt Blue wash to dry, then wet the boat above the top edge of the hull and the water surrounding the boat. Using your 1-inch (25mm) flat, put an orange mixture of Alizarin Crimson and Indian Yellow into the cabin area letting it bleed and spread. Before everything dries, drop in some pure Alizarin Crimson in a similar way, letting it bleed and feather into the surrounding colors. Put in a sharper line of Alizarin Crimson along the top of the hull with the edge of your 1-inch (25mm) flat. While you're at it, place a couple spots of Alizarin Crimson on the waterline of the boat and let them bleed into the water.

Wet the foreground water with your hake and wash pure Phthalo Blue through the lower section of the water.

As the paper begins to dry, load your 1-inch (25mm) flat with a runny mixture of White gouache and splash it onto the water in front of the hull. This can get pretty messy, which is good—choppy water rarely looks tidy—so you may wish to lay down some scrap paper over the sky to protect it from splatters of paint.

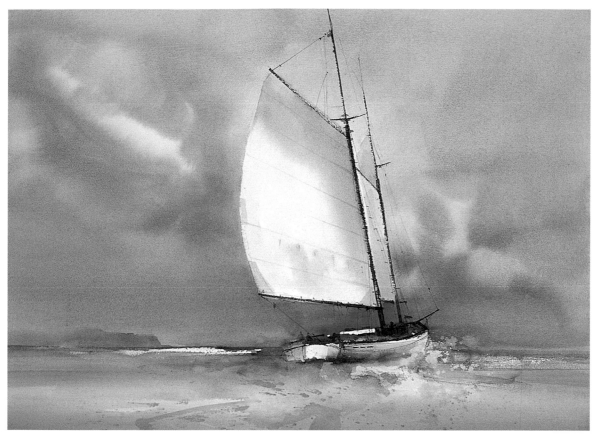

6 Set it to Sail

This is where a few strong, confident lines can really pull your painting together. To paint the masts, booms and spars, use your ¼-inch (6mm) flat or a mid-size round sable if you have one. Mix a rich brown from Burnt Sienna, Alizarin Crimson and Indian Yellow. Load your brush and use the dragging technique, starting from the top of the main mast. Remember to hold the brush very lightly at the end of the handle and drag it slowly toward you, putting no downward pressure on the bristles. You will have to turn your painting around so you can drag these lines toward you. Use this technique for the other mast and spars.

To do the ropes and rigging, use your rigger brush and a neutral gray mixed from Burnt Sienna and Ultramarine. Hold the brush perpendicular to the paper and turn your painting so you can draw the lines across from, left to right if you are right handed and vice versa. Don't attempt to draw them toward you or away from you, and remember to make bold, sweeping motions from the shoulder; don't use finger or wrist movement. Don't be too concerned if the lines are not in exactly the right spot. A smooth, confident line a little off target looks much better than a nervous wobbly line in exactly the right place.

All you need now are a few more details: some stitching and reinforcement in the sail, a few lines and marks on the hull and a couple red spots to give the impression of detail in the cabin area. Use a strong opaque red like Cadmium Red or Scarlet Lake and your ¼-inch (6mm) flat to get a nice sharp rectangular shape. The suggestion of a distant headland on the left lets us know the boat is heading out to sea. Use your 1-inch (25mm) flat brush and a cool gray mixed from Alizarin Crimson, Ultramarine and a little Phthalo Blue. As soon as you apply the shape, rinse and slightly dry your brush and run it along the top edge of the shape to soften it.

Tip Don't overwork your rigging. A few very fine lines and a couple dots to suggest pulleys are all that is needed. Just remember to keep your lines straight, thin and confident!

Sandstone Reflections

This painting is based on my sketches of a sheer sandstone wall rising above a deep pool of water. The late afternoon sun enhanced the wall's rich texture. Vegetation dotted the ridge and accentuated the brilliant blue sky. This is an ideal subject for you to experiment with a combination of various texture techniques. You will use washed and sprayed ink, cling wrap and Japanese rice paper to build up a rich and complex-looking texture. A flat Ultramarine sky really adds drama to this impressive subject.

[MATERIALS LIST]

Paints
- Alizarin Crimson
- Phthalo Blue
- Quinacridone Gold
- Ultramarine gouache
- White gouache

Brushes
- 1-inch (25mm) Taklon flat
- No. 12 mop brush
- No. 2 Taklon rigger
- 3-inch (76mm) hake

Paper
- 140-lb. (300gsm) Arches rough
- Textured Japanese rice paper

Other Supplies
- Old bristle brush
- PVA glue (craft glue)
- Burnt Sienna ink and pen
- Cling wrap

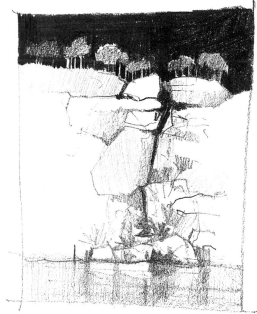

This pencil sketch is the basis for this colorful and textured painting.

1 **Begin with Ink**
Applying ink to a clean sheet of paper might seem like a frightening way to start a painting. Don't be timid, though. Draw Burnt Sienna ink straight onto a clean sheet of watercolor paper, wait a couple of minutes, then scrub it off with a water spray. Draw in some rock shapes with the suggestion of a fracture about two-thirds of the way across. Apply Burnt Sienna ink with a brush handle or an eye dropper to ensure that a large amount of ink is deposited. Wait two or three minutes, then, holding the paper perpendicular to the ground—so the ink runs toward the bottom of the painting—saturate it with your spray. Most of the ink will be washed away, leaving an interesting variety of lines.

2 | **Clinging to Texture**

Spread a pale, watery wash of Quinacridone Gold and Alizarin Crimson around the rocky outlines you created in the last step. Drop in a couple spots of strong Burnt Sienna and a little Ultramarine close the fracture line, then cover the wash with cling wrap. Push the cling wrap around to form a rocky texture. Allow it dry thoroughly before removing the cling wrap. You should find some interesting textures to keep in your finished painting and some not-so-interesting bits you can work over as the painting progresses.

3 | **Add Pizazz with Paper**

Add more variety to the texture of your painting by tearing out two or three pieces of Japanese rice paper of varying sizes and shapes. Try to find a paper with interesting texture. I used one that contains little flecks of chopped plant matter.

Move the shapes around to find a pleasing position, then attach them with diluted PVA glue. You may have to press a clean piece of paper on top of the rice paper to make the papers stick properly to your painting.

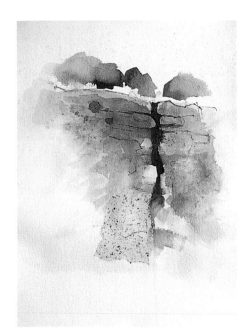

Don't Forget the Greens

4 Create a mixture of Burnt Sienna, Quinacridone Gold and Phthalo Blue. Using this mixture and your 1-inch (25mm) flat, put in the scattered trees. Keep the tone at the top of the trees light enough to contrast the dark sky. Later you will paint the dark blue sky around the trees with gouache, so their shape and any hard edges can be adjusted.

Mix some more Burnt Sienna and Phthalo Blue into the tree color on your palette, and put in the dark line of the fracture in the rock wall. Cut it in around some of the rock shapes made by the washed ink. Feather out some parts of the fracture line to suggest shadows on some of the rocks. Stir some water into the green mixture on your palette. With your 1-inch (25mm) flat, soak up as much of the mixture as possible and splash it onto the rocks on the left. If the splashes appear too dark, blot them carefully with a tissue.

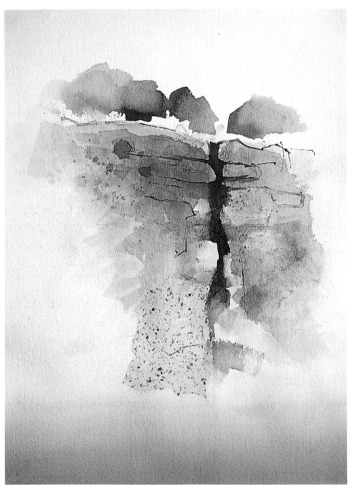

Water Your Foreground

5 Wet the bottom quarter of your painting and put in a graded wash of the blue-green mixture of Phthalo Blue and Quinacridone Gold. Feather out the top edge of the wash with a clean, damp brush so it disappears seamlessly into the rocks above.

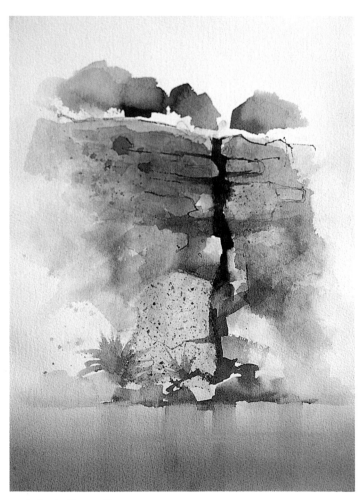

Just a Suggestion

6 Suggest rocks and bushes along the waterline to make the rock wall appear to sit above the water. Paint these details with your 1-inch (25mm) flat and varying combinations of Quinacridone Gold, Phthalo Blue and Burnt Sienna. While the darker tones are still wet, drag them down into the water with a clean, damp brush to form the reflections. Use a mixture of Burnt Sienna and Ultramarine to add a little more definition to the rocks in the wall.

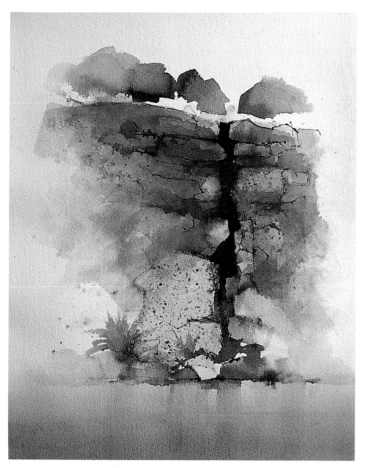

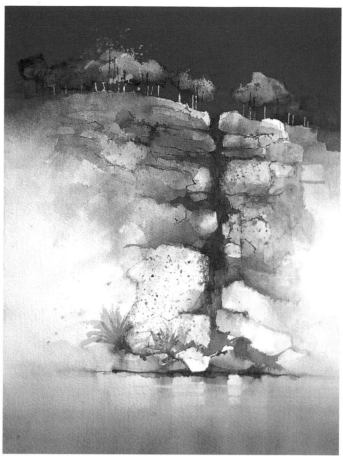

7 | Feather on the Texture

Now you can really make the rocks come to life. Mix a rich red from Alizarin Crimson and Quinacridone Gold, and work it through the upper section of your rock wall. Gradually lessen the intensity as you go down the wall. A combination of splashing and feathering will add to the wall's texture.

Let the red color dry, then draw in some Burnt Sienna ink lines with your dip-in pen. Quickly spray the ink while it is still wet. The lines will break up into fantastic spidery, textured marks, giving the rocks an ancient, weathered appearance. Work these lines through the center of interest and down along the fracture line. By now your painting should be fairly wet—a good opportunity to put some life into the fracture line. Drag some pure Ultramarine down the dark area of the fracture line with a sharp stick or thin brush handle, twisting it as you go.

SANDSTONE REFLECTIONS • mixed media • 14" × 11" (36cm × 28cm)

8 | Complement the Rocks

Make the orange rocks really vibrant by painting its complementary color blue next to them. Mix some Ultramarine gouache with a tiny bit of water to paint in the flat, blue sky. Wet the trees before carefully and evenly painting in the sky with your 1-inch (25mm) flat. While the sky is still wet, use a clean, damp brush to feather the blue into the rocks toward the edge of the painting.

Once the sky dries, add some more trees with a dark mixture of Quinacridone Gold, Burnt Sienna and Phthalo Blue. Splash in other trees with a lighter green made by adding White gouache to the previous green mixture. Mix it on a separate palette or wash off the splatters after you paint the trees. Don't get gouache into your transparent watercolors. Before you clean up your gouache, use your rigger brush to add some tree trunks. Mix a little Burnt Sienna into the white to prevent too dramatic a contrast with the sky. Put in a few dark trunks for variety too.

Use a mixture of Ultramarine and Burnt Sienna to put a little more modeling into the rocks. Apply the paint with your mop brush and use your damp 1-inch (25mm) flat to feather the marks where necessary. You can also use some of this dark color on the foreground details. Finally, strengthen the water with another graded wash of Phthalo Blue.

Forest Light

Have some fun experimenting with masking fluid, sandpaper and gouache to capture the filtered light breaking through a forest of small trees.

[MATERIALS LIST]

Paints
- Alizarin Crimson
- Burnt Sienna
- Phthalo Blue
- Quinacridone Gold or Indian Yellow
- Ultramarine gouache
- Ultramarine
- White gouache

Brushes
- 1-inch (25mm) Taklon flat
- No. 12 mop brush
- No. 2 Taklon rigger

Paper
- 140-lb. (300gsm) Arches rough

Other Supplies
- Small, old bristle brush
- Brown pastel pencil
- Masking fluid

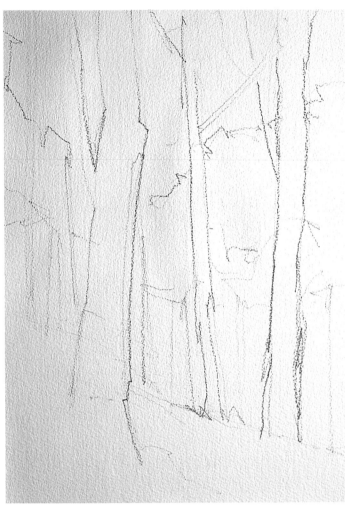

1 | **Begin with a Sketch**
Sketch in your tree shapes with a brown pastel pencil. Make the lines strong and confident. Many will become part of your final painting.

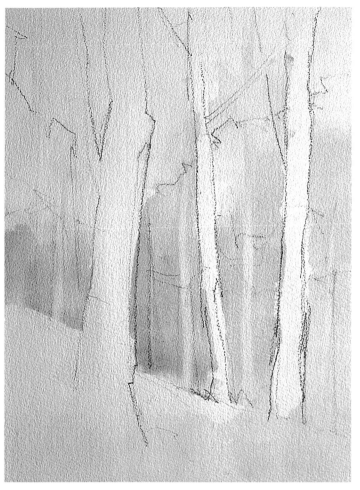

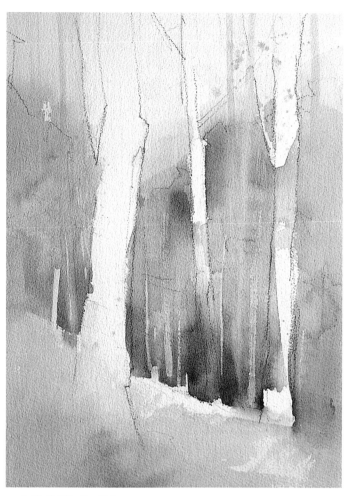

2 | **Mask the Trees**
Mask a few thin, vertical lines with a small, old bristle brush.
Vary their size and spacing. Don't worry if the lines are a bit
rough and scratchy, they will look more natural than if they
are clean and sharp. Let the masking fluid dry, then wash on
pale Raw Sienna. Grade it out toward the top of your painting
and leave some white paper on the hillside around the main
tree. Don't be too fussy cutting around the trees; they will
eventually be painted a darker color. Before this wash dries,
lift out a few vertical lines for distant tree trunks with the edge
of your damp 1-inch (25mm) flat.

3 | **Build Up the Color**
Let your first wash dry, then add a few more vertical lines of
masking fluid. This time, mix a wash of Burnt Sienna and
Phthalo Blue, applying it in a similar manner to the last wash,
grading it out toward the top. Before the wash dries, drop in
some Indian Yellow and Burnt Sienna to vary the color through
the background. Again, lift off a few distant tree shapes.

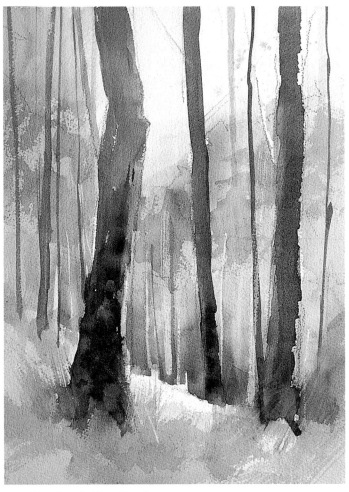

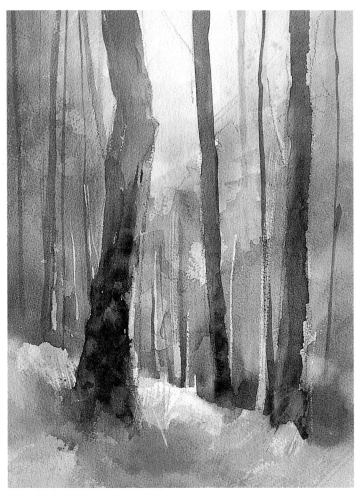

4 | **Develop the Tree Trunks**

Add life to the dark silhouette of the tree trunks using a dark combination of Ultramarine and Burnt Sienna. Paint the three largest trees with your 1-inch (25mm) flat. While the trees are still very wet, drop and splash in some pure Alizarin Crimson and Ultramarine. Add the smaller trees and saplings with the tip of your mop. Again remember to vary the spacing, thicknesses and directions. Stir in a bit of Phthalo Blue and Indian Yellow to this dark color on your palette. Dilute the mixture with a little water and add some more foliage. Drag the paint roughly with your 1-inch (25mm) flat almost parallel to the paper. The back end of the bristles—near where they meet the ferrule—will leave wonderful broken marks, ideal for the texture of foliage. Warm up the foreground with a loose wash of Burnt Sienna and Indian Yellow. Create the grassy marks in the foreground by drying your 1-inch (25mm) flat, spreading out the bristles and dragging them through the wet paint.

5 | **Push for Depth**

Simplify and push back the background of your painting by introducing a green-gray wash down either side of painting and across the line of the hill. Make the green-gray mixture with Ultramarine, Burnt Sienna and Indian Yellow. Keep the edges very soft and make sure to maintain the white area of the sky. While the wash is wet, splash in some Alizarin Crimson and add some of the darker green along the line of the hill.

Add a wash of Alizarin Crimson and Indian Yellow to the area under the main tree to bring the foreground closer. Vary the edges of the wash, and while it is wet, drop in some pure Alizarin Crimson.

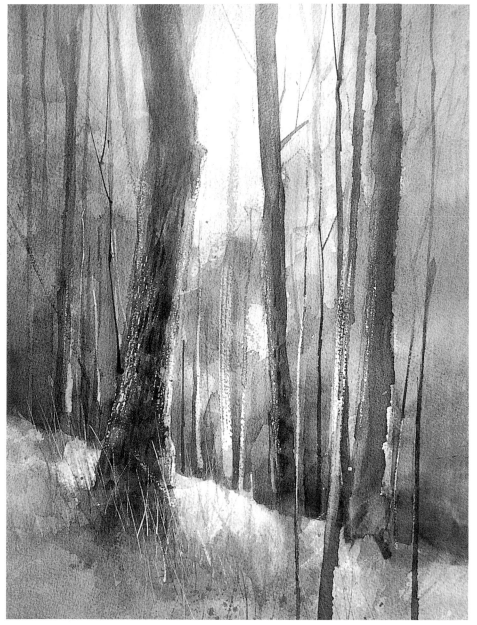

FOREST LIGHT • 14" × 11" (36cm × 28cm)

6 | Let the Sun Shine
Remove your masking fluid at this stage. You may find that the light areas revealed are too raw and sharp to be left as they appear. Before adjusting them, use some sandpaper and a sharp blade to suggest light on the edges of the larger trees. Now you can adjust the masked areas and any of the sanded or the scraped sections at the same time with a warm gray wash.

Help steer the eye to the center of interest with some soft gray shadows leading in across the foreground. Use a mixture of Ultramarine and Burnt Sienna and make them very soft—just enough to take your eye across the foreground. Make the foreground shape more interesting by breaking it up; extend a couple of the minor trees down across the foreground and out of the bottom of the painting. Increase the feeling of depth with a strong wash of Ultramarine in the region behind the foreground hill. Grade a wash of Cobalt Blue through the upper foliage to add depth.

Use your rigger brush and some White gouache mixed with a tiny amount of Indian Yellow to put some grass detail into the foreground. Add some dark lines of grass and a few thin twigs in the upper foliage. Finish your painting by putting spots of pure Ultramarine gouache in the dark area of the main tree with a sharp stick.

more easy
TIPS & TRICKS

In this chapter we will look at mastering the basic elements that make up a painting. Discover the importance of planning and drawing. Look at the roles tonal values, color harmony and the center of interest play in making a painting a success. ⑥ A painting with mediocre technique and well-planned composition can be successful, but even the best technique in the world can't save a mediocre composition ⑥ No matter what you paint, planning is vital. I'll teach you how to pull apart your subject and rearrange it into a successful composition. You will then look at key points to take the mystery out of painting a variety of different subjects.

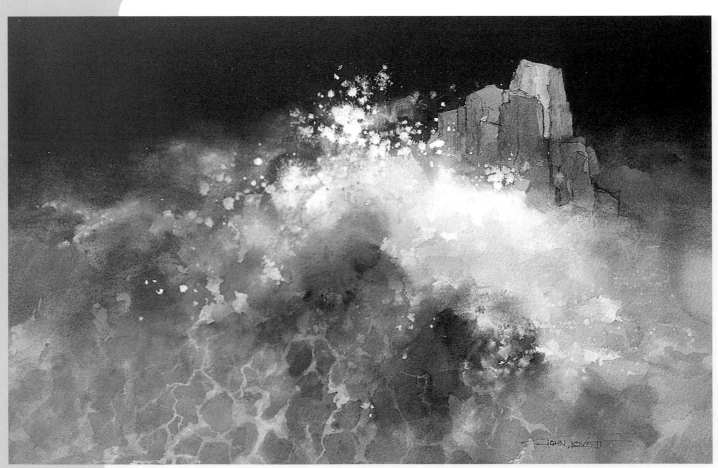

SEA SPRAY • 14" × 20" (36cm × 51cm)

Helpful Hints

Thumbnail sketches are a way of shuffling around shapes, tones and ideas before you start to paint. They only need to be about the size of a credit card and can be done quickly with a soft lead pencil. The first thing to do is reduce your subject, no matter how complex, to five or six major shapes. Try grouping areas of similar tones. For example, the shadow under a veranda, a group of adjacent trees and a distant mountain of the same tone may all be grouped into one dark shape in your thumbnail. Don't worry too much about details; your thumbnail sketch should be as simple as possible—a few spots of dark and light around the center of interest is all the detail necessary.

Once you have broken your subject down into a few major shapes, you may want to move some of them around or alter their size and profile to make a more pleasing composition.

Your thumbnail also allows you to experiment with the boundaries of your painting. Simply drawing another rectangular border—higher up or lower down over your thumbnail—lets you see what the painting might be like with a large foreground and the subject pushed to the top or a dominating sky and center of interest at the bottom.

There is no escaping the fact that drawing plays a major role in most paintings. Whether it's the initial sketching or the final details applied with brush or pen, most marks made on your painting require the ability to draw. Unfortunately there are no shortcuts to becoming a good drawer; it simply requires lots of practice. Have no fear, unlike piano scales or swimming laps, the practice is very enjoyable.

You can buy large drawing sketch pads for a couple of dollars, and they provide plenty of cheap paper to scribble on. I fill one every four or five weeks drawing thumbnails, sketching things, redrawing and rearranging paintings or jotting down ideas.

Drawing on a large scale will also build confidence and control. Any large paper will do—blank newsprint, brown paper or cheap cartridge—the bigger the better.

Joining a life drawing class is also a good way to gain confidence, while working on a large scale. Don't feel intimidated because you are a beginner; people are more interested in what their own work is like, not other members of the group.

Draw as often as you can. Don't try to produce nice finished drawings; think of it more as training. Teach your hand to recreate what your eye sees or what your brain tells it.

Thumbnails let you plan your painting before you even put a brush to paper. Producing a good painting is much easier when you have some sort of plan to follow.

The accidental nature of watercolor means that any plan, no matter how detailed, is just a guide, though sometimes, certain little accidents will cause you to deviate from your thumbnail. That's okay, consider your thumbnail more as a starting point for your painting than a plan you must follow.

Drawing on a large sheet of paper forces you to loosen up your drawing and makes your lines much more confident.

Stand up and work on a vertical surface. If you are using charcoal or pastel, lean your drawing slightly toward you at the top so the dust doesn't spill down across your drawing. The technique for large works is different from the technique from drawing in sketch pads. The lines will be made with big, sweeping arm and body movements, not just finger and wrist movements. Hold the pencil between your thumb and all four fingers for more control and to take away the temptation to use small, fussy strokes.

Tonal Values

Tonal values or tones indicate how light or dark something is. They have nothing to do with color, though all colors have a tonal value.

The arrangement of tonal values in your work has a huge bearing on the impact you create. Don't simply follow what you see. Try different options and choose the one that you find most satisfying.

Also consider the overall tone or key of your painting as well as the relationship of tones within your painting. Some subjects are better treated with an overall light tone and these paintings are referred to as a high-key paintings. Other subjects are more suited to a dark tone—a low-key painting.

To gain maximum tonal contrast with watercolor, it is necessary to leave some areas of white paper in your painting. You must decide where these white areas will be before you start to paint. Think about where your lightest tone washes will go, as these are the first washes you will apply. Getting these large, high-key washes on quickly and simply at the very start of your painting stops the painting from becoming too fussy and overworked.

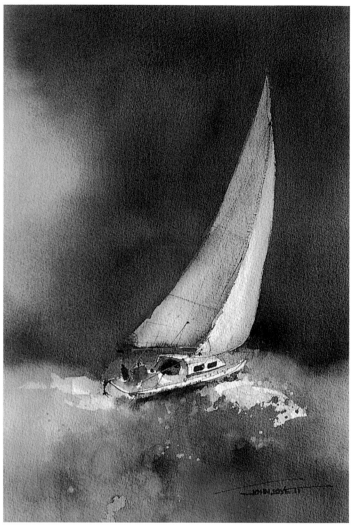

The drama and excitement of an ocean squall are best expressed with strong tonal contrast and an overall low tonal value or key.

These three thumbnails show the same subject in three tonal arrangement with black, white and three grays. In each case, the strongest tonal value contrast occurs at the center of interest, but the different tonal arrangements still greatly affect the mood of each sketch.

I did this painting on a full sheet of paper. I applied most of the washes with an old 2-inch (51mm) house painting brush. I worked out the sequence of washes before I started the painting. I built a number of very pale yellow-brown washes up over the whole surface, except the area of sky and buildings. I gradually lowered the tone of the washes until I placed in the dark shapes of the trees. I added the Cobalt Blue sky and mauve mountains after the warm washes had dried. Finally, I added detail and painted the red roofs. Working from light to dark in this way meant that my large, pale washes quickly and loosely covered the paper—keeping the painting fresh—while the darker shapes overtop formed the details.

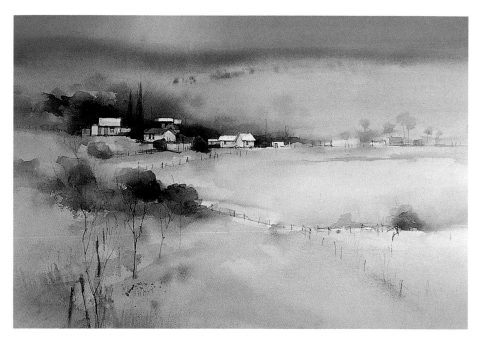

I used a stark, high-key arrangement to convey the highly strung, irrational nature of this large, powerful bird with a very small brain.

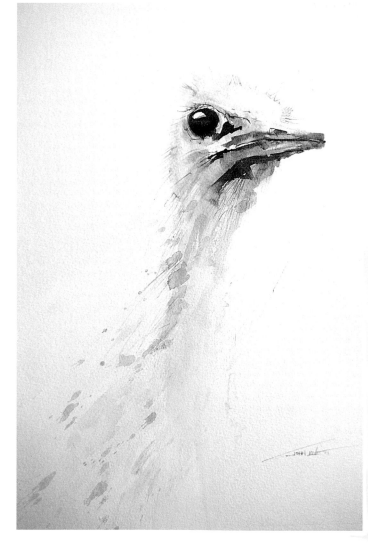

Tip One of the most common reasons that a painting looks dead and lifeless is lack of good, strong, dark tones. Even a high-key painting can take advantage of the full range of tones. For maximum impact, your tonal range should span from pure white paper to rich, intense, dark colors. In many cases, the reason that rich, strong, dark tones are difficult to achieve is that the artists have not squeezed enough pigment onto the palette. So use plenty of pigment and you will find that producing a successful painting is much easier.

Center *of* Interest

When working out the composition of your painting, one of the first things you should think about is your center of interest. It should be the most interesting part of your subject. Avoid placing the center of interest in the horizontal or vertical center, unless you want a formal, static composition. Remember, it is the center of interest, not the center of your painting. Try to locate the center of interest at an unequal distance from each of the four sides of your work. It should be the area in your painting with maximum tonal contrast—the adjacent darkest dark and lightest light. Using a contrasting color at the center of interest will also hold the viewer's attention in this area.

Establish a pathway through your painting. Lead the viewer's eye into the painting and up to the center of interest. From there the eye should wander out to minor points of interest comfortably, always returning to the center of interest. One option for a simple composition is to arrange the center of interest and and two less important points in the shape of a triangle with sides of different lengths.

THE GOLDEN MEAN

The golden mean is a relationship of height to width based on the golden rectangle discovered by the Ancient Greeks. The golden rectangle has a length approximately 1.618 times its height. The Greeks saw this as the perfect and most beautiful proportion. Much of their architecture, painting and pottery was based on this relationship. This same relationship is common in nature and has found its way into the artwork of many different cultures. We don't have to be precise about the relationship—1:2 is close enough and 3:5 is even better—but it is important to keep these proportions in mind whenever you make a mark on your painting. Whenever you divide a line, intersect or position shapes, or locate your center of interest in relation to the boundaries of your painting, aim for somewhere around this relationship. A line or shape divided evenly in half creates little interest; both sides are the same. It is stable, static and boring. A line or shape divided in the ratio of, say, 9:1 certainly isn't boring; it's quite the opposite! This relationship is extremely off balance and creates a lot of tension. A line divided in the proportions of the golden mean, or about 1:2, is interesting to look at without creating tension or a feeling of imbalance.

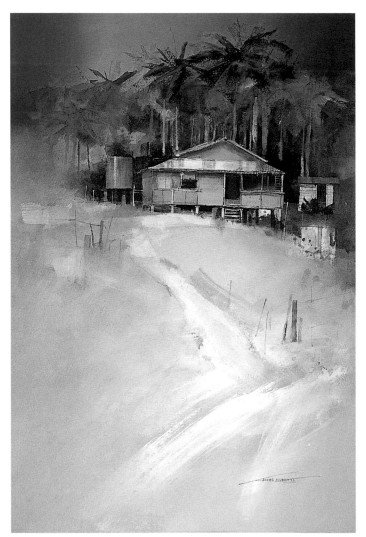

The detail on the right-hand side of the building forms the center of interest in this painting. A section of road makes an interesting line for your eye to follow from the bottom of the painting up to the center of interest. The minor area of interest at the bend in the road in the foreground and another around the water tank encourage the eye to move in a comfortable, triangular pattern around the center of interest. Fine detail, strong tonal contrast and a splash of Alizarin Crimson draw the eye constantly back to the center of interest.

Color Harmony

The term "color harmony" refers to colors that relate to one another. Selecting adjacent colors on the color wheel will provide color harmony, but without some contrasting complementary color, composition looks a bit bland and uninteresting.

It is important to plan your color arrangement. Aim to have a singular, dominating color temperature in each of your paintings—either predominately cool with a smaller amount of contrasting warm or predominately warm with a smaller amount of contrasting cool.

Don't simply copy the colors of your subjects. Extract the colors you want, then consider how to get the most impact from them. You may have to eliminate some, pull some closer to the dominant color in your painting or make some more or less saturated. You have complete control over the colors in your painting, so take advantage of this to see just how you can manipulate what the subject presents.

This example shows nice, tight color harmony using the blue and blue-green regions of the color wheel. Although harmonious, the color arrangement is a bit unexciting.

The addition of a complementary red adds some life and excitement to the composition.

In this painting the warm reds and golds of the fallen leaves produce a tight color harmony and warm color temperature. The addition of intense Ultramarine into the shadows adds life and transparency, and focuses attention on the center of interest.

The cool greens and grays in this painting form a harmonious, cool, dominant color temperature. Introducing Alizarin Crimson to the center of interest adds excitement to what could have been a dull, uninteresting painting.

Limited Palette

One way to keep your colors under control is to limit your palette. You can use just one warm and one cool color to do an entire painting, forcing you to not rely on the actual colors of the subject.

Try various combinations of warm and cool colors from around your palette. You can get a good idea of what your painting will look like by placing a patch of each pure color you plan to use side by side and blending them in the middle.

After trying a few paintings with a two-color limited palette, sneak in a third color. Continue to aim for tight color harmony using your third color as an accent to add life to the painting.

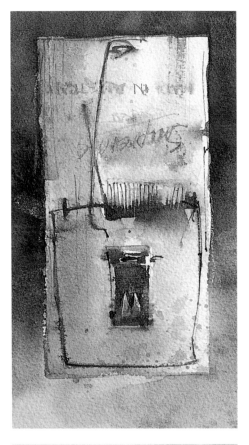

This is not the most attractive subject, but it's great fun to paint. I painted this old rat trap on paper glazed with Raw Sienna. I used Burnt Sienna and Ultramarine, introducing a couple spots of Alizarin Crimson toward the end.

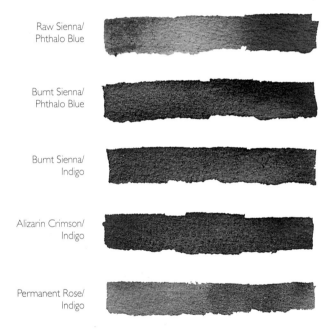

Raw Sienna/
Phthalo Blue

Burnt Sienna/
Phthalo Blue

Burnt Sienna/
Indigo

Alizarin Crimson/
Indigo

Permanent Rose/
Indigo

Here are some warm and cool combinations. Experiment with these and you will be surprised at what you can achieve with just two colors. When you select a combination, try to match it to your subject. The Permanent Rose/Indigo combination, for example, is very soft and subtle compared to the Phthalo Blue/Burnt Sienna combination which is warm and earthy.

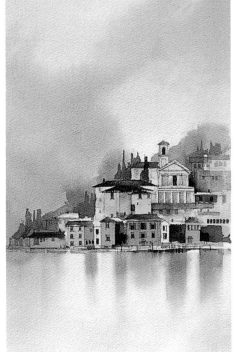

I did this little piece with just Burnt Sienna and Phthalo Blue. I did most of the painting with a mixture of the two colors, that leaned toward Burnt Sienna. I added a few small accents of both pure pigments to add some life while maintaining a tight color harmony.

Alien Colors

Sometimes you will see a painting with a color that just doesn't fit—a raw green tree or a lonely, red roof—something that jumps out of the painting and really doesn't belong. The reason for the color's alienation is that it was probably not linked in any way to the rest of the painting.

To avoid this problem, repeat any contrasting colors in two or three other locations throughout the painting. You can make these repeating areas less intense; even soft, transparent washes will work.

Tie-Up Colors

Another way to unite disjointed colors in your painting is to use a tie-up color. This is a fine, interesting line of color traced through the painting. It can be applied with a liner brush or with a pen and colored ink. The important thing to remember when you are applying a tie-up line is to keep it interesting. Vary the thickness, tone and type of line. It can be rough, scratchy, smooth, soft, feathery, etc. You can easily create interesting variations if you use pen and ink, then spray water on the fresh line. The secret with paint and a liner brush, is to have your clean, damp, 1-inch (25mm) brush handy to adjust the lines as you apply them.

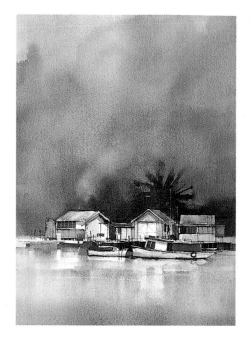

Permanent Rose brings the predominant green of this painting to life. At first glance it appears to be just the roofs of the buildings, but there are traces of Permanent Rose through the water and also a soft wash through the top right of the painting. These subtle traces make the rest of the painting relate to the accent color.

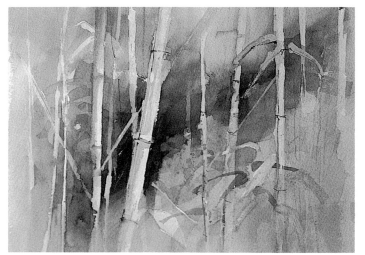

This painting is almost finished, but it needs something to pull it all together.

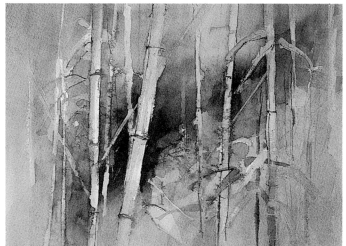

Here you can see the unifying effect of fine tie-up lines. I applied blue ink lines with a dip-in pen and then sprayed them with water before they dried.

Neutral Dark Colors

Neutral dark colors are the dark areas in your work that don't lean toward warm or cool. They appear flat, black and uninteresting and can zap all of the life from a painting. It is impossible to accidentally mix a flat, neutral dark with Alizarin Crimson, Indian Yellow and Ultramarine (or Phthalo Blue.) Not to worry, it is an easy problem to fix! If your dried mixture becomes a neutral dark, simply wet the area and put in some pure Ultramarine or Alizarin Crimson to revitalize it. The tricky part is to be aware of the problem and watch out for it.

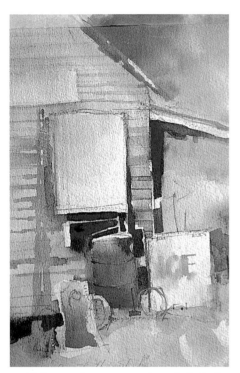

I added pure Ultramarine to these dark shadows to give them a life and transparency that is missing from a neutral gray or black.

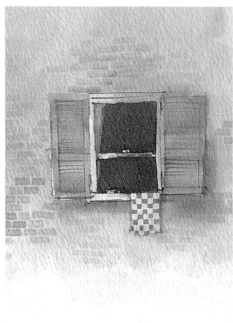

The temperature of dark colors has a big influence on the impression of depth in your work. Look at these two windows. On the left, the dark color is a warm, brown hue that tends to come forward and sit on the surface. On the right, the cool, dark blue recedes and gives the impression that you are looking into the room.

Overworking

One of the biggest problems with watercolor is overworking. "The hardest part is knowing when to stop," is a common cliché for watercolor painting and is certainly worth thinking about. The temptation to fix up and finish off can be overwhelming, but remember that sometimes the most beautiful aspects of a painting are the simple, understated areas left to the imagination.

Don't be afraid to leave areas of white paper or simple washes. The contrast between these areas and the carefully worked details can give a painting much more impact than spreading detail to every corner.

Try not to become too focused on one area of your painting, always try to look at the work as a whole. It is OK to have scruffy, sketchy parts or plain, simple parts or highly detailed parts or even rough, unfinished parts. How all these separate areas unite determines whether or not the painting is a success. For this reason it is important to have a clear, unobstructed view of your painting at all times. Trying to work with brushes, photographs and tubes of paint covering your painting makes it very difficult to observe changes to the painting as a whole.

This subject can tempt an artist to carefully render every detail. But if you focus on the most interesting details and understate the rest, the eye follows a path through the painting rather than jumping randomly all over the place. First, I washed the understated areas in quickly and simply with a 2-inch (51mm) flat. After this initial wash dried, I scrubbed diluted gesso over the top. This left a rough, textured finish. Without these simple, understated abstract areas, my painting would lose much of its mystery and become more of a record of the scene than an interpretation.

Tailored Tips *for* Your Favorite Subjects

Landscapes

The temptation to accurately record everything you see can really spoil a landscape painting. Careful planning and editing make all the difference. The best approach—whether working from photographs, sketches or on location—is to start with some quick thumbnail sketches. Shuffle things around until you have a composition you are happy with. This composition becomes the framework into which the information in front of you is placed.

Look carefully at your subject and decide what attracted you to it. Is it the color, the composition or the light? Or is it simply a place that means something to you? Knowing exactly what appeals to you will help you see what to change or eliminate.

Don't try to squeeze too much detail into a landscape painting. Simple areas of relief help give impact to the detailed areas. Be careful to limit the amount of tonal contrast. Little patches of white paper, particularly those small areas left around the edges of your painting, are a common problem here. They tend to make your painting look busy and confused. If you find these areas around the edge of your work, simply wash over them to reduce the contrast and make your painting much easier to look at.

Your treatment of edges can reinforce or destroy the feeling of depth in a landscape. A hard, sharp edge will come forward and a soft, broken edge will recede. Keep your distant shapes softer and foreground objects or center of interest sharper and more defined. Decreasing tonal contrast and color saturation will also push distant objects further back into your painting.

The light tone and soft, broken edge of the distant hill in this painting keep it pushed well into the background. A slightly harder edge above the center of interest on these distant hills draws the eye from the edges of the painting back to the focal point.

The late afternoon light and simple curve of the river attracted me to this subject, but I changed the color completely. The fields were actually a vivid, saturated green, which would have overpowered the painting.

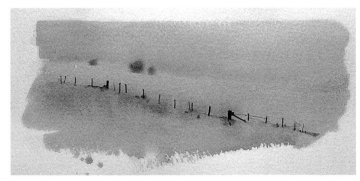

It is hard to do landscape paintings without, at some stage, including fences. These can become boring, repetitive elements unless you make a conscious effort to make them interesting. The best way to give fences some sort of character is to vary them.

Vary the size, color, tone, spacing or angle of the posts. The eye can read the fence with a single glance and also look at individual parts, giving more depth and interest to the painting. Incorporate variety into any repeating elements in your paintings, even if they are minor elements.

Trees

Watercolor and cold-pressed or rough paper combine ideally for painting trees and foliage. Randomly drag a large, flat brush almost parallel to the paper to produce the perfect texture for foliage.

It is good practice to draw trees, paying particular attention to the negative shapes between the branches and foliage. Also, pay attention to the size, angles and intersection points. After you have drawn a few trees this way, you will develop a much better understanding of their structure and be able to paint them more convincingly.

Sketches can be rough and unfinished. Their purpose is simply to help you observe and understand the structure of trees.

Because trees usually are lit from above, use some darker pigment in the lower part of the foliage. Burnt Sienna and Phthalo Blue make a wonderful green. Vary the mixture slightly by adding a little Indian Yellow, but be careful not to make the color too green. The green in most trees contain a fair amount of red, and it is safer to make your trees too brown than too green. Keep the edge of the foliage interesting. Make some rough parts, some hard edges and some soft and feathered edges. Have fun splashing and dropping in paint; there is no need to be fussy or careful.

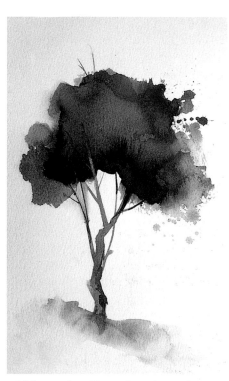

Add the trunk and larger branches with your $1/4$-inch (6mm) flat. Use your liner brush for the finer twigs. As the branches get thinner, make them lighter in tone; this helps give them a finer appearance. If you have gaps in your foliage where the background wash shows through, it may be necessary to darken them slightly to ease the contrast and keep them from leaping out at you. You can give a solid tree a three-dimensional feeling by changing the tone of a branch where it crosses the foliage from dark against a light background to light against a dark background.

Flowers

Flowers make great subjects for paintings. They are full of color and pattern and can be treated in many different ways.

Composition should be a major consideration when your subject is flowers; you can arrange them in a variety of ways to generate different feelings in the viewer. Compositions can range from the more traditional, formally arranged vase of flowers placed squarely in the middle of the painting to vibrant, abstracted arrangements full of movement and excitement. Think carefully about the placement of your flowers within the boundaries of the painting. Choose an area to be your center of interest and keep your strongest tonal contrast there. Try a very light flower against an extremely dark background or a dark flower against a pale background. Flowers at your center of interest also should have the hardest, sharpest edges. Turn attention to your center of interest by softening the edges and decreasing the tonal contrast of less important flowers.

Carefully consider your backgrounds for floral subjects; if you are painting dark flowers that require a pale background, paint the background first. It is much easier to wash it in leaving a few white spaces for the flowers than it is to try cutting in around the finished flowers. You can also increase the tonal contrast at the center of interest and make your watercolors more interesting by varying the tones in your background.

Try to get some movement through your painting unless you are after a formal, static arrangement. Use the lines of stems and leaves to set up a path through the painting, leading the eye into and out of the center of interest. A dark band through the background will also lead the eye through a group of light-toned flowers or a band of light will lead the eye through a group of dark flowers.

Color contrast is another useful device for floral subjects. Select complementary colored flowers or use a complementary background to give the colors more impact and produce a more vibrant painting.

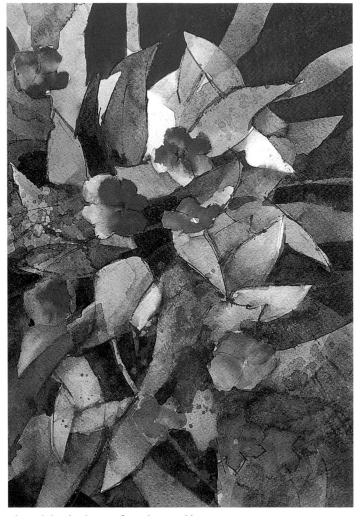

The subdued colors, softer edges and lower tonal contrast in the foreground of this painting encourage the eye to move up to the center of interest.

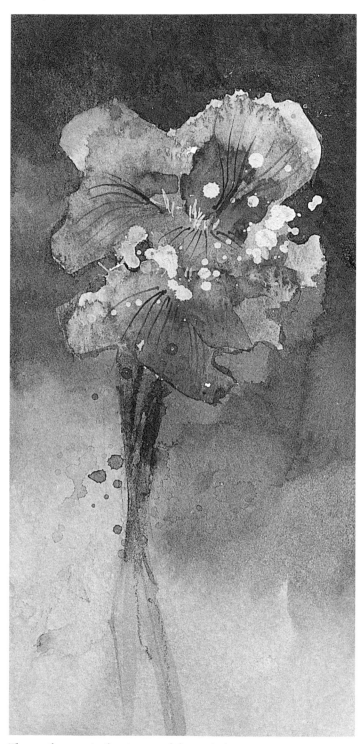

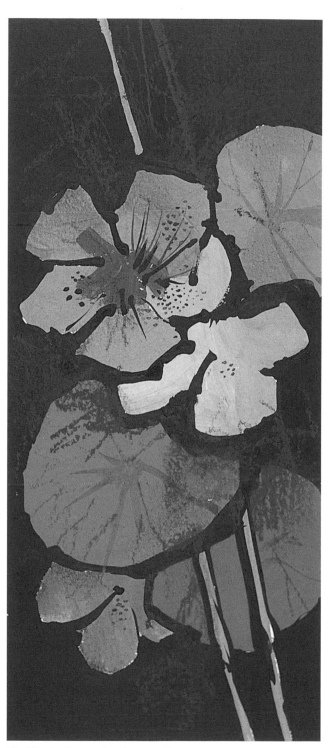

The gentle curve in the stems and the graded tones in the background carry the eye up to the point of strongest tonal contrast at the top of this flower.

The blue background and orange flowers in this painting are complementary colors. Place them next to one another to increase the intensity of both colors. In this painting I also used gouache to get a flat, graphic effect that also adds to the color's intensity.

Water

Water in your paintings can vary from a flat, static foreground with mirror-like reflections to a raging sea that dominates the painting. Creating these different scenes all require you to use a variety of techniques, but there are a few common points for water reflections.

Tone and color are compressed in reflections, so dark colors will be slightly lighter and lights will be slightly darker. Colors will be less saturated and may be influenced by the color of the water.

The color of the water itself can vary greatly, but water generally tends more toward a green-blue; for this reason Phthalo Blue is a good base for water.

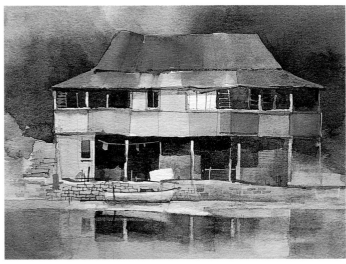

Here I compressed the tonal values and subdued the colors with a wash of Raw Sienna, which gave the reflection a convincing subtlety.

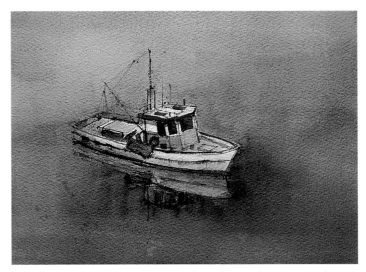

The high vantage point in this piece shows how reflections vary from a mirror image. The deck and cabin top are visible on the fishing boat, but cannot be seen in the reflection.

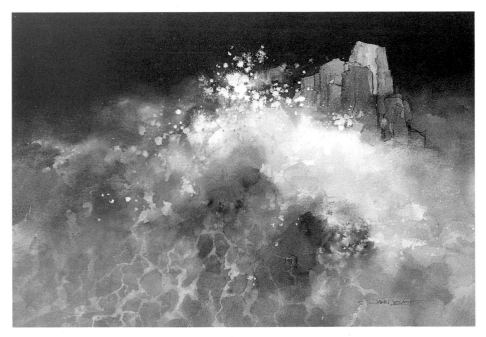

This painting uses a combination of Ultramarine and Prussian Blue (very similar to Phthalo Blue) in the water and a mixture of Ultramarine and Alizarin Crimson in the sky. I started the foreground texture as a pale wash and built up the small mosaic patches over it leaving the pale wash showing through. The breaking wave is a combination of white paper and splashes of white gouache. I used a contrasting warm color for the rock to establish a center of interest.

Sky

The secret to successfully painting a sky is to use plenty of water, work quickly and stop once it starts to dry. Apart from the hard line formed by the edge of a sunlit cloud, most skies are soft and graded—a good opportunity for working wet-in-wet. Your sky can be anything from a simple flat wash to a swirling mass of light and clouds.

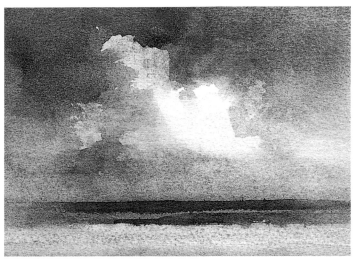

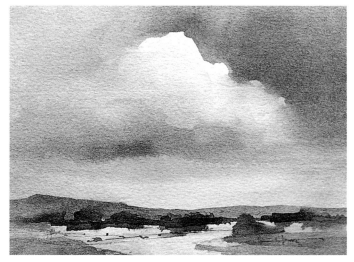

These two simple paintings feature the sky as a major part of the painting. They are painted on a quarter sheet divided into four with masking tape. Experimenting on a small scale like this helps build confidence and lets you try different color combinations and techniques before launching into a larger painting. Keep a note of the colors and techniques you used—they make a useful reference in later paintings.

I used Alizarin Crimson, Ultramarine, Prussian Blue and a little

Raw Sienna for the first example. I painted it very wet and lifted the cloud shapes out with a crumpled paper towel.

I painted the second example with Cobalt Blue, Ultramarine, Rose Madder and Raw Sienna. I painted the sky first, very wet except for the hard edge on the cloud. I added landscape features after the sky had thoroughly dried. I also added drama with the strong, horizontal shadow cast by the cloud.

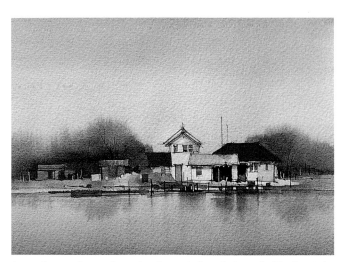

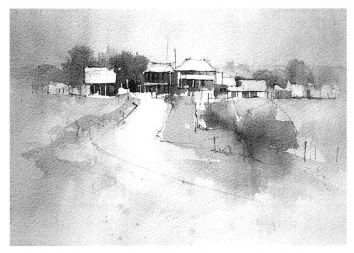

Apart from a flat wash, a simple graded wash is probably the easiest treatment for a sky. I allowed an initial wash of Rose Madder to dry before applying a graded Cobalt Blue wash.

In this little sketch, I took the graded wash a step further. This time I did the wash with the painting turned sideways. It changes from dark to light and back to dark again. The resulting band of light in the sky focuses attention on the center of interest. Plan this type of wash from the start or use it over an existing sky to bring the eye back to the center of interest.

Buildings

Buildings make fascinating subjects for paintings. They can tell wonderful stories of the lives and activities carried on around them. Their geometric form makes them easy to understand and paint, but the challenge is to look beyond the physical characteristics and try to capture the character that gives them life. This requires observation and interpretation, but first you must understand some of the mechanics of painting.

Tip The most important thing to remember is that buildings are based on right angles, so keep your vertical lines close to vertical.

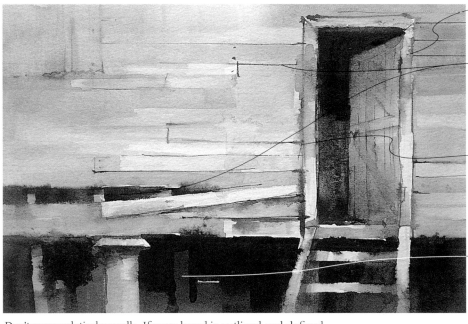

Bracing on doors, gates etc. always slopes up from the hinge side.

Placing a shadow at the top of these studs or posts makes them appear to sit under or behind the piece of timber they support.

Weather boards will always join on studs (where you find the vertical rows of nails). Doors and windows usually fit between one or two studs.

Make the shadowy area under raised buildings interesting by suggesting posts and details.

Don't overwork timber walls. If every board is outlined and defined, the surface becomes confusing and monotonous. Leaving part of the wall plain and indicating boards elsewhere gives the area much more interest and variety. Vary the tone and color of some boards to add interest.

Vertical lines are parallel so right angles look correct.

These lines, although they do not form right angles with the ground, work because they counteract each other.

These lines all lean in the same direction and look wrong.

Roofs

Drawing roofs is much simpler when you gain an understanding of their structure. This knowledge allows you to fill in details you can not see and correct optical illusions caused by bad light, obscuring foliage or poor photographs. Don't be afraid to paint a complicated-looking roof. When you break these structures down into their various elements, they become quite easy to draw!

When painting the roof surfaces, keep the light source in mind. Also the flatter the pitch of the roof, the lighter the tone. Make the building surfaces interesting; splits between sheets of iron, grades in tone and variation in color and texture all give the roof character.

Avoid rounded corners and convex lines on roofs or they will tend to look like a thatched roof. If anything, make roof lines slightly concave and exaggerate the sharpness of corners. This applies to windows and doors too. Keep the corners square and sharp—this is where your flat, square brushes really make life easy.

Also, consider how to place buildings in your work. Make either the building dominate with very little landscape or the landscape dominate with the building as a center of interest. Other structures can frame the scene and create interesting compositions that give relief to the main area of detail.

Drawing a hip roof is easier when you remember that no matter what angle the building is viewed from, the two outermost slopes (A & B) will have the same angle and slope C will change according to the angle of view.

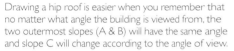

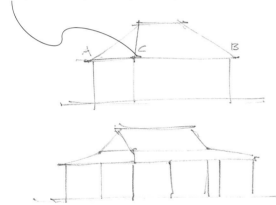

Many roofs are a combination of hips and gables. Common cottage construction often has a gable roof surrounded by a low-pitched hip veranda.

More elaborate buildings have a hip roof and veranda with a gable over the entry.

Many cottages are extended as the family grows. The roofs on these rambling extensions look complicated but are usually just a combination of hips and gables.

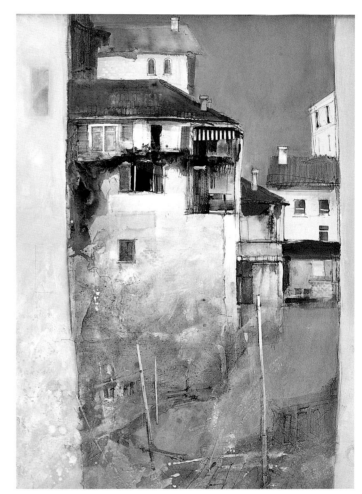

Framing the main buildings in a stone opening not only adds depth to the painting, but also enhances the feeling of scale, forcing the viewer to look down into the foreground water and up at the buildings above.

OLD STONE WALLS • mixed media on gesso board
48" × 36" (122cm × 91cm)

Find Your Style

As you gain confidence working with watercolor, your own preferences, likes and dislikes will begin to steer you toward a certain way of painting. Be aware of this, and as you learn, absorb as many different influences as possible.

Practice

It is easy to become disheartened when things just don't seem to go right. Don't worry though, everyone goes through it. Put the failures aside and start something fresh and perhaps less ambitious. Just keep working and don't dwell on the few paintings that don't turn out as well as you would like. Try to paint as often as possible. If you find it hard to make time, try some small quick paintings—use only about one-eighth of a sheet—a couple of times a week. The more you practice, the easier it becomes!

Experiment

Try different subjects that you wouldn't normally consider painting. Don't think about whether or not they will sell or what friends and neighbors might say. Indulge yourself and have some fun! I have painted everything from worn out sand shoes to concrete mixers and have enjoyed every minute of it. It is interesting how strange and unusual subjects can force you to think more about design and composition. You can't rely on the appeal of the subject to carry the painting. In fact, sometimes the subject might be quite unappealing and all those abstract elements and principles must be used to coax an engaging work of art from an unattractive subject.

Tip Now try developing your own style. Visit exhibitions, attend different workshops, read books and magazines, watch videos. Just be open minded. The broader the range of influences you expose yourself to, the easier it will be for you to develop a style that is truly your own.

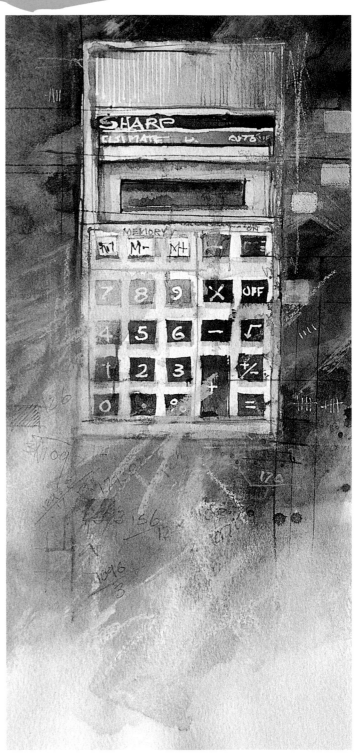

Ordinary, everyday objects, like this calculator, are fun to paint. The challenge is to expand on them, give them some life and amplify their character.

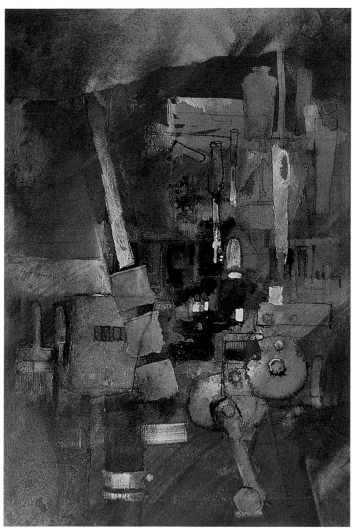

Another interesting approach is to zoom right in on your subject. The painting must first work as a purely abstract design, allowing the identity of the subject to emerge upon further inspection.

You can have great fun stretching the subject into an almost purely abstract form. This painting, based on the strange collection of tools in a shipwright's cabin, contrasts the warm friendly timber implements with the cold blue ocean they float above.

Sometimes things we consider fairly unattractive make great subjects for paintings.

Conclusion

By the time you have worked your way to this part of the book you will probably have produced quite a few paintings. Some you will be really proud of, some you may have wanted to tear up and others will sit somewhere in between. Cherish your successes! Look at them and enjoy them, frame them and hang them on your wall. These are the paintings that will pull you out of those frustrating periods when nothing seems to go right. Expect to produce some disasters, but put them aside and move on. Your best paintings are the ones to gauge your progress by.

For me, one of the most fantastic things about painting with watercolor is the fact that I am forced to observe, analyze and judge things in greater detail. A little box of paint, a couple of brushes and a piece of paper become the catalyst for a more intense perception of all I see. This by-product of the process of painting is well worth all the ups and downs you may go through. It becomes much more than a hobby or career; it will make you see the world in a whole new way.

Good luck and have fun!

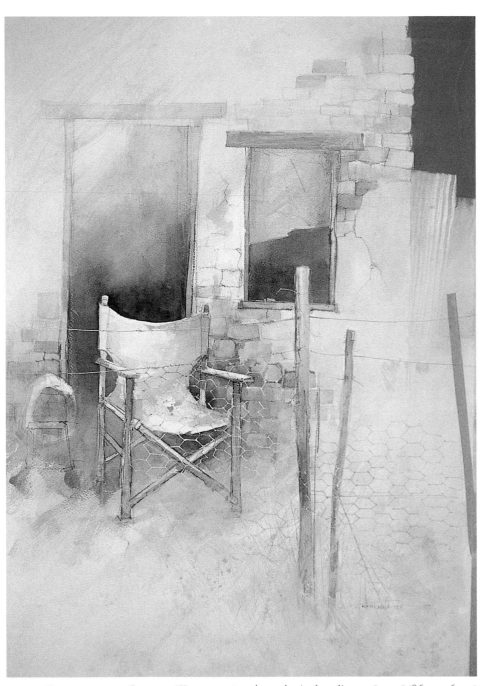

THROUGH THE BROKEN WIRE • watercolor and mixed media • 34" × 24" (86cm × 61cm)

Index

Explore watercolor painting with North Light Books!

North Light's Big Book of Painting Watercolor Flowers—Readers can paint their favorite flowers in watercolor, brush up on the basics and create finished pieces in no time. Includes easy step-by-step demos.

ISBN 1-58180-625-6, paperback, 192 pages, #33198

Beautifully illustrated and superbly written, this wonderful guide is perfect for watercolorists of all skill levels! Gordon MacKenzie distills over thirty years of teaching experience into dozens of painting tricks and techniques that cover everything from key concepts, such as composition, color and value, to fine details, including washes, masking and more.

ISBN 0-89134-946-4, HARDCOVER, 144 PAGES, #31443-K

Traditional Chinese watercolors capture the essence of natural objects with a profound, unmatched beauty. Renowned artist Lian Quan Zhen shows you how to paint in this loose, liberating style through a series of exciting, easy-to-follow demonstrations. You'll learn how to work with rice paper and bamboo brushes, then master basic Chinese brushstrokes and compositions principles.

ISBN 1-58180-000-2, HARDCOVER, 144 PAGES, #31658-K

Paint Luxurious Textures in Watercolor— Texture is one of the most crucial elements of any successful painting. Now readers can discover the secrets of this powerful technique with 15 demos that show how to create texture for a variety of subjects from embroidered silk to smooth surfaces like silver to animal fur.

ISBN 1-58180-515-2, hardcover, 128 pages, #32874